SCULPTING BASICS

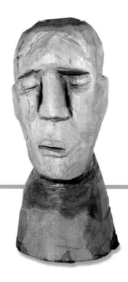

SCULPTING BASICS

EVERYTHING YOU NEED TO KNOW TO CREATE
FANTASTIC THREE-DIMENSIONAL ART

KARIN HESSENBERG

A QUARTO BOOK

First edition for the United States and Canada and its territories and possessions by Barron's Educational Series, Inc. 2005.

All inquiries should be addressed to:
Barron's Educational Series, Inc.
250 Wireless Boulevard
Hauppauge, NY 11788
www.barronseduc.com

ISBN-13: 978-0-7641-5843-8
ISBN-10: 0-7641-5843-0
Library of Congress Catalog Card No.
2004115830

QUAR.SCR

Conceived, designed, and produced by
Quarto Publishing plc
The Old Brewery
6 Blundell Street
London N7 9BH

PROJECT EDITOR: Paula McMahon
ART EDITOR: Stephen Minns
COPY EDITOR: Claire Waite Brown
DESIGNER: Tania Field
PHOTOGRAPHER: Geoff Morgan
ASSISTANT ART DIRECTOR: Penny Cobb
PROOF READER: Robert Harries
INDEXER: Pamela Ellis

ART DIRECTOR: Moira Clinch
PUBLISHER: Paul Carslake

Manufactured by Provision Pte Ltd Singapore
Printed by Star Standard Industries Pte, Singapore

9 8 7 6 5 4 3 2 1

CONTENTS

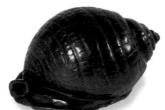

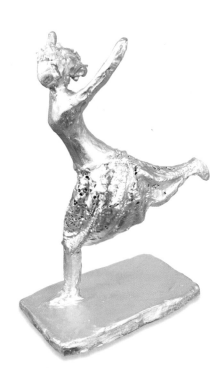

INTRODUCTION

Humans have been painting and sculpting since prehistoric times. Where painting is a two-dimensional art form, sculpture is three-dimensional and can be viewed from all around, and the act of sculpting engages your senses of sight and touch as well as your intellect and emotions.

MATERIALS

Carving and modeling are the two main sculptural techniques. Traditionally, sculptors have carved many kinds of stone and wood, and carved stone sculptures have been excavated from prehistoric sites all over the world. There are also examples of bone and ivory carvings from this epoch, but few carved wood sculptures have survived.

Modeling with clay took on greater importance with the development of pottery. Clay could be fired to create durable, hollow terracotta sculptures or used to make models for casting in bronze, gold, or silver. Most metal sculptures have first been modeled in clay or wax before being cast in a mold.

Learn how to work with wood.

In the twentieth century, materials such as rubber, fiberglass, resins, and plastics became available to sculptors, opening up a whole range of new possibilities. Modern sculpture can be constructed using a variety of techniques and materials, from welding metal to composing structures from found objects and mixtures of different media.

Discover techniques for capturing likeness.

TECHNIQUES

This book illustrates the fundamental techniques of sculpting and shows you how to use the basic materials. It will arm you with the knowledge you need to create beautiful works of your own. The process of making sculptures is time-consuming, laborious, and requires patience. You will need to spend time working with your chosen materials until you are familiar with them and confident in handling them. Then you should make practice versions or dummy runs of your planned sculpture before you begin on the real thing. However, if you work methodically and plan in advance—particularly with carving—and keep persisting, you will be rewarded with success, satisfaction, and pleasure.

Master a range of tools and materials.

HOW TO USE THIS BOOK

Because sculpture encompasses a range of materials and techniques, this book has been divided into four sections, each containing a set of projects aimed at building your skills with materials and processes. Each section contains an introduction to the materials and clearly demonstrates the general techniques you need to know in order to start on the projects.

Clay modeling is dealt with in the first section, with a grounding in important techniques, followed by projects that help you practice them.

Working with plaster, mold making, and casting is introduced in the second skills section of the book.

Direct building uses some of the materials and techniques covered in the previous section.

Carving is covered in the fourth section of the book, using materials and tools that are easy to manipulate and inexpensive to buy.

There is a final section devoted to **finishing techniques**, illustrated with demonstrations on sculptures made in some of the projects.

It is a good idea to practice the methods featured in the Techniques pages of each section until you are thoroughly familiar with them. Most of the materials used in this book are relatively inexpensive, so you can afford to make mistakes: don't expect to get things right on your first attempt. Unfired clay sculptures can be soaked in water to recycle the clay, but set plaster will have to be thrown away.

Finally, at the end of the book there is a list of useful reference books and some recommended reading if you wish to progress to more advanced sculpture techniques.

In addition to the basic tools featured on page 8, the specific tools and materials required for each process are described at the beginning of each section.

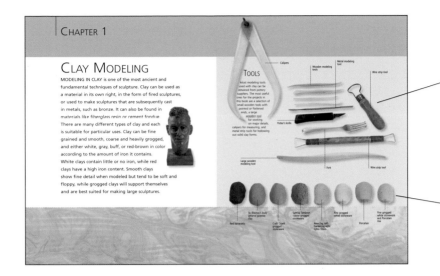

The tools required to get you started in each section are all labeled.

The crucial materials for each section are shown on this page.

Each process entails specialist skills. Learn these and you are ready to start the projects.

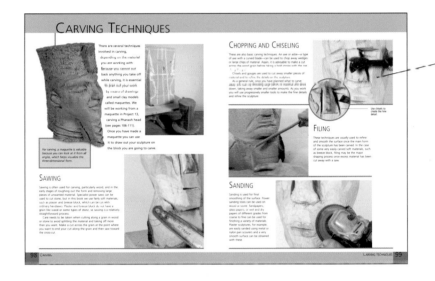

The techniques necessary to complete the projects are accompanied by photographs, so you will have all the information you need.

In each section, the projects are organized by degree of ease. You can progress from one to the next.

Each project features the finished item for you to copy, or for inspiration.

Everything you need for each project is listed for you.

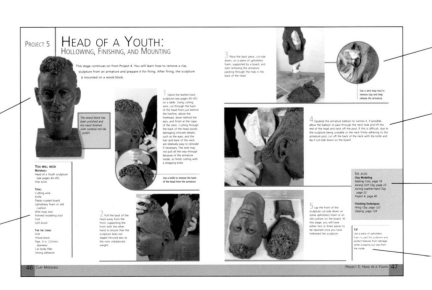

Important details are singled out for greater clarity.

The projects are set out in easy-to-follow step-by-step instructions, with photographs.

The skills required for each project are cross-referenced, so moving around the book is easy.

Throughout the book you will find tips and handy hints that will help with your work.

Getting Started

Before you begin to learn the various sculpting techniques, you need to consider where you will be working and what you will need, and make sure you understand the safety aspects of sculpture.

Workspace and Equipment

You will not need to buy lots of expensive, specialist tools to use the methods described in this book, unless you plan to fire clay sculptures, in which case you will need a kiln. Some forms of sculpture require specialized equipment but these are generally beyond the scope of this book.

Mallet

Workspace
First and foremost, you will need a workroom where you can make a mess. The floor should be washable and the room should have a large, sturdy table to work on. A water supply and sink are also essential.

Wood saw

Tools
A selection of basic household tools will be useful. Depending on the materials you plan to work with, some relevant tools would be a wood saw, hacksaw, chisels, rasps, files, drill, hammer, and mallet, as well as pliers and wire cutters.

Surform rasps

Specialist Tools and Equipment
You will also need modeling tools for working with clay and plaster. These are obtainable from pottery suppliers and sculptors' suppliers. The more commonly used shapes of modeling tools can also be bought from good arts and crafts stores.

Wood chisel

A kiln is an expensive item to buy, so it can be a good idea to ask a local college, adult education center, or a local potter, to fire the work for you. They will often provide this service for a small fee to cover the cost of firing. If you do wish to buy a kiln, an electric kiln is the most suitable for domestic use, and some small hobby kilns can run off an ordinary household circuit. Larger kilns capable of firing up to high stoneware temperatures will run on the type of circuit used for electric ovens. Most pottery suppliers and kiln manufacturers make a range of kilns and will give you all the advice you need for installation and setting up.

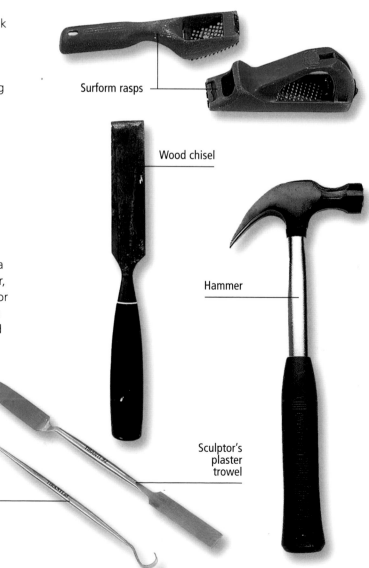
Hammer

Sculptor's plaster trowel

Griffon rasp

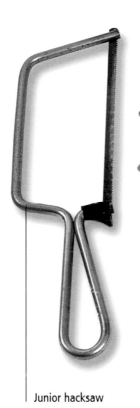

Pliers

Wire cutters

Junior hacksaw

HEALTH AND SAFETY

Dust is the first health problem in sculpture. Dry clay produces a hazardous dust, so do not allow clay to dry out on boards or on the table or floor. All surfaces where clay has been used should be thoroughly washed with water. Three rinses on tables and three washes with a mop for the floor is recommended.

When working with dry powders such as plaster, or filing dusty materials such as cinder block, wear a dust mask. You can also spray water into the air with a plant mister to settle any dust.

Always wear an apron when working and use an old towel for wiping your hands. Rinse these out thoroughly at the end of the day and wash them regularly, remembering to rinse them out well before putting them in the washing machine.

Rubber gloves should be worn when working with materials that can irritate or injure the skin, such as cement fondue. Wet plaster can dry out and irritate the skin, so put barrier cream on your hands or wear rubber gloves. Gardening gloves or similar sturdy gloves should be worn when handling chicken wire. In projects where gloves are needed, they are listed in the materials and tools section.

Spray paints have strong fumes, so use them in well-ventilated conditions.

Most projects will not involve the use of power tools; however, Project 14, wood carving, offers the option of working with a small chainsaw (see pages 112–117) and, in this case, goggles, ear protectors, gloves, and a dust mask are a must.

Other safety considerations are based on common sense. Take care when using a chisel with hand pressure not to have your other hand in the way, in case the chisel slips. If using a mallet with a chisel, it is advisable to wear a glove on the hand holding the chisel.

KILN

If you need to buy a kiln, think about the size. You should select a kiln that is neither too large nor too small for the amount of use.

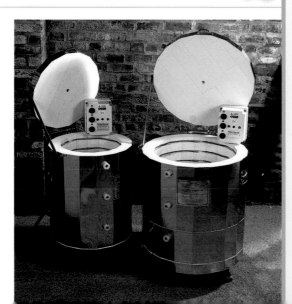

SOURCES OF INSPIRATION

Sources of inspiration for sculpture are many and varied, from naturally occurring phenomena to other people's work, so be prepared to take an existing concept and adapt it to fulfill your sculptural aims.

Throughout civilization, sculpture has been made for specific purposes. Bronze, wood, or stone statues honor kings or military leaders, or represent deities and other religious figures. Assyrian relief carvings tell the stories of military campaigns, while carved wood screens in churches depict biblical scenes. These carvings and sculptures told stories to populations that were once largely illiterate.

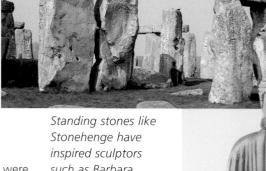

Standing stones like Stonehenge have inspired sculptors such as Barbara Hepworth and Henry Moore.

It was not only human figures that were depicted. Animals have great significance in many societies. Sculptures of bulls, horses, or lions, for example, range from enormous statues at the portals of buildings to small clay votive figurines. Sculptures of sacred cows are located in Hindu temples in India. Small-scale sculptures of animals, birds, or humans appear as gold, jade, or ivory ornaments. Similarly they can be represented in fired clay such as the Chinese terracotta army or, on a smaller scale, porcelain figures from Dresden.

Representational sculpture may be loaded with symbolism and religious meaning, while other forms of sculpture may be more abstract. Abstract sculpture is mostly associated with the twentieth century, but the standing stones or megaliths erected in the Bronze Age are highly abstract and have symbolic meaning.

It is possible to find inspiration for sculpture in almost anything that surrounds us, such as animals, plants, shells, pebbles, geological formations, and the human figure. We may wish to make a portrait, or express a feeling through a more abstract and expressionistic treatment of a human head or figure. Henry Moore and Barbara Hepworth found inspiration in rocks or standing stones from landscapes they loved. The projects in this book will also help you to find sources of inspiration by looking at different forms and working in a variety of media.

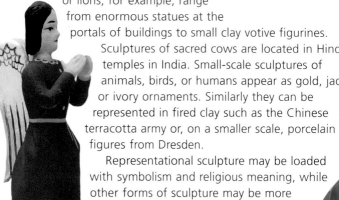

From small-scale traditional art, like this Peruvian clay figure, to local flora and fauna, and large-scale religious carvings, the world around you is a great place to start looking for ideas.

Nature has its own way of creating beautiful objects.

DESIGN BASICS

The word design is more often associated with making furniture or clothing than with an art form like sculpture. However, there are design principles underpinning sculpture that need to be taken into account.

VOLUME AND MASS

Sculpture is essentially a three-dimensional art form, so volume is the defining characteristic of a sculpted artwork. All free-standing sculptures can be viewed from all angles, and it is their size and shape that gives the sense of volume. A megalith or standing stone that is a carved-out, single piece of stone can be three times the height of a man, or a smaller stone about knee height arranged in a circle of similar stones. Each stone has its own volume according to its size.

A simple form, such as an egg, pebble, or megalith comprises a single three-dimensional shape. This shape is a mass that has its own volume. More complex forms, such as a human figure, consist of several masses of different volumes. The head is a different size from the body and both are solid bulky masses, while the arms and legs are slender, elongated forms. The whole figure can be regarded as several masses of differing volumes. Try separating the head from the torso. It is relatively easy to see these as two separate masses. It is important to bear this in mind when looking at the overall form of a sculpture. For example, making a human figure with arms and legs as thick as the body would create a very strange and unrealistic form.

The overall mass of a form should be borne in mind when working on any sculpture.

The toad, Project 9, is a good example of mass and volume (see pages 74–79).

PLANES

When starting out on a sculpture, it is sensible to visualize the form in terms of the major planes. A plane is two-dimensional. It can be the flat front of a box, the triangular side of a pyramid, or the curved plane of a cheek or forehead on a portrait. A piece of paper is a good example of a plane. It is very thin as seen from the edge, but the rectangular surface area can be flat or made to curve between your hands. It is important to think about the top and bottom views of a sculpture as well as the front, back, and sides.

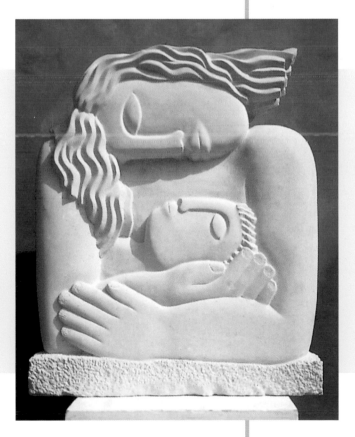

This sculpture shows the figures carved on one plane to emphasize the emotion of the pose.

LINE

Line is an element normally associated with drawing, but it is also important in sculpture. The pose of a figure can be represented in the form of lines, such as in stick-men drawings. When sculpting a figure, the position of the arms, legs, body, and head need to be observed carefully. Many sculptures are modeled in clay on a supporting framework called an armature. If the directions or lines of the armature are in the wrong place, it is very difficult to sculpt the correct pose.

Line can also be used to create a sense of movement or shape. Vertical lines can give a sense of height, while diagonal lines give a sense of direction and tension. Curved lines may create the impression of movement or flow.

This dancing figure is a good example of lines indicating movement.

The lines in the dancing figure of Project 10 (see pages 84–89) indicate movement, while the lines of the arms and legs were the basis for constructing the armature. The shape of the spaces between the arms and legs of the figure also defines the overall form of the sculpture. Space between different masses is another important consideration, particularly with groups of figures or forms.

SCALE

The scale of a sculpture needs a lot of thought. In an outdoor setting the sculpture works best if it is large and monumental; otherwise it becomes dwarfed and insignificant in relation to the landscape. Smaller sculptures are better displayed indoors where they relate to the human scale.

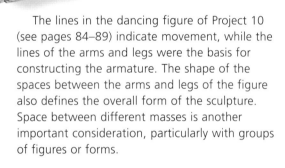

Outdoor sculptures offer the opportunity to work on a grand scale.

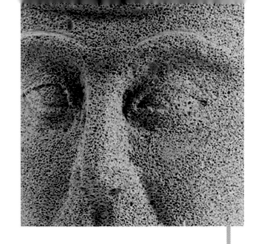

SURFACE

The surface of a sculpture will ultimately define the character of the final piece. Polished, gleaming surfaces that reflect light can enhance the features on smoothly worked clay, stone, wood, or metal. Rough or textured surfaces tend to absorb light and may need more emphatic modeling or carving so that fine detail does not get lost. The two head projects (Projects 5 and 13) in this book, for example, have very different surfaces.

The clay sculpture, above left, was finished with polish and reflects light, enhancing the features. The cinder block sculpture, above, absorbs light.

Pebble dash

Scrunched polythene

Saw blade

String

RELIEF

Relief sculpture can be molded, see projects 6 and 7, or carved, as above.

Relief sculpture occupies its own special position somewhere between a picture and three-dimensional sculpture. It cannot be viewed from all sides.

In low relief, the figures are only slightly raised from the background, but high relief may contain elements that are almost fully three-dimensional.

Metal kidney

Fine scrim was used to add texture to the clay sculpture at the top of this page, but almost any material could be used to produce a surface texture on clay or plaster.

CLAY MODELING

MODELING IN CLAY is one of the most ancient and fundamental techniques of sculpture. Clay can be used as a material in its own right, in the form of fired sculptures, or used to make sculptures that are subsequently cast in metals, such as bronze. It can also be found in materials like fiberglass resin or cement fondue. There are many different types of clay and each is suitable for particular uses. Clay can be fine grained and smooth, coarse and heavily grogged, and either white, gray, buff, or red-brown in color according to the amount of iron it contains. White clays contain little or no iron, while red clays have a high iron content. Smooth clays show fine detail when modeled but tend to be soft and floppy, while grogged clays will support themselves and are best suited for making large sculptures.

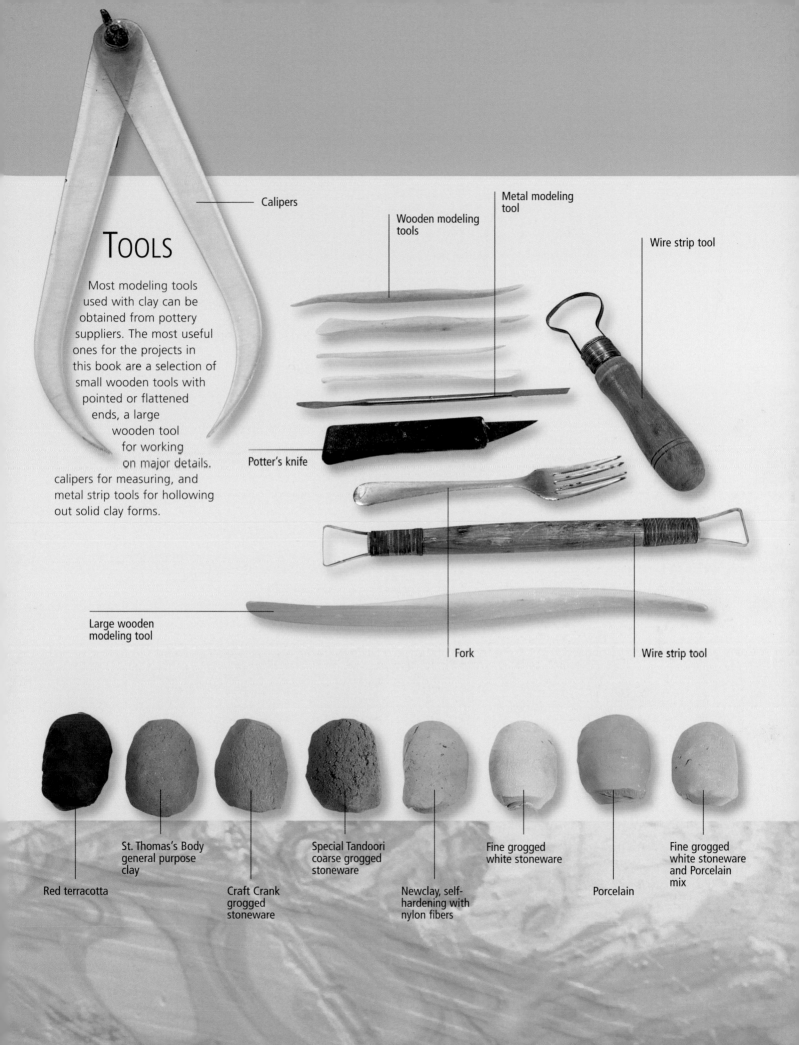

Calipers

TOOLS

Most modeling tools used with clay can be obtained from pottery suppliers. The most useful ones for the projects in this book are a selection of small wooden tools with pointed or flattened ends, a large wooden tool for working on major details, calipers for measuring, and metal strip tools for hollowing out solid clay forms.

Wooden modeling tools

Metal modeling tool

Wire strip tool

Potter's knife

Large wooden modeling tool

Fork

Wire strip tool

Red terracotta

St. Thomas's Body general purpose clay

Craft Crank grogged stoneware

Special Tandoori coarse grogged stoneware

Newclay, self-hardening with nylon fibers

Fine grogged white stoneware

Porcelain

Fine grogged white stoneware and Porcelain mix

PREPARING CLAY

Wedging and kneading are techniques for ensuring that clay has an even consistency for making pottery or sculpture. The clay should be soft and malleable but not sticky or sloppy. It also should not be so stiff that you cannot comfortably squeeze it into shapes with your hands.

For most sculpture projects, new clay can be used straight from the bag without any further preparation. However, clay that has previously been used and recycled may be poorly mixed, with some stiff lumps and other areas where the clay is too soft. Wedging followed by kneading will bring the clay back to a good, working state. Wedging and kneading can also be used to mix different sorts of clay, as illustrated here. Wedging takes only a little practice while kneading requires more experience because, if not done correctly, air bubbles can become trapped in the clay.

YOU WILL NEED

MATERIALS
Clay

TOOLS
Cutting wire

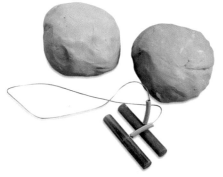

WEDGING

Wedging is the best method for mixing clay, whether you are mixing two different clays or just mixing stiff and soft clay of the same type. It consists of cutting a lump of clay in half and slamming one half on top of the other.

1 Make a lump of clay by slamming a ball of one clay on top of a ball of the other clay. Turn the lump over and slam it onto the table to flatten the layers.

2 Cut the lump in half with a cutting wire. Slam one half on top of the other as before. Turn the clay over and cut again.

3 Continue slamming, turning, and cutting to mix the clays. The different-colored layers in the clay will start getting thinner.

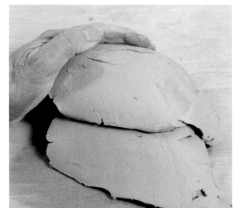

4 When the clay has a completely even color, with no hint of wavy lines in the cut section, it is ready to use.

KNEADING

YOU WILL NEED
MATERIALS
Clay

Kneading clay has the exact opposite purpose to kneading bread dough. For bread, the aim is to incorporate air so that the bread is light. With clay, the aim is to squeeze air out.

Kneading takes practice, but with patience you will master the technique. Practicing this technique also gives you the feel of the clay so you learn how it responds to your hands.

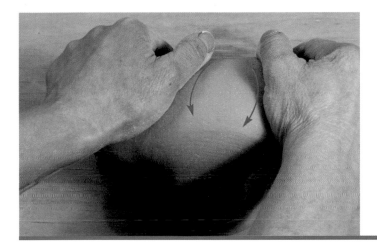

1 Take a lump of clay big enough for your hands to fit over. Use the heels of your hands to push the clay back onto the tabletop. Do not allow your fingers to spread out straight. Keep them curled over to lightly grip the clay. This prevents the lump being completely flattened on the tabletop.

2 Move your fingers under the clay from the back and stand the piece almost upright. Then push the clay back down again, still keeping your fingers curled over the lump.

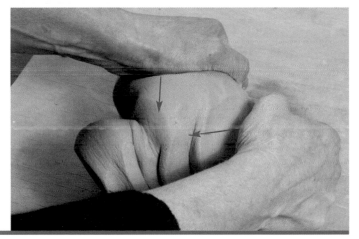

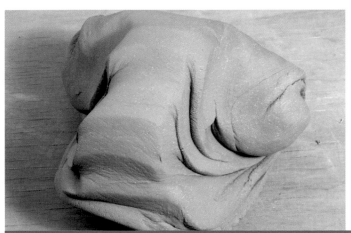

3 The clay looks like a sheep or ox head. Think of kneading as rocking the head back, then hitching it up again to stand on its nose. Move the heel of your hands onto the eyebrow area and push back again. At first, you will find that you are making big eye sockets in the head which will cause trapped air as you fold the clay over itself. Concentrate hard on not going into the eye sockets but working from above the eyebrow so that the clay is turned in a series of small waves that squeeze air out. You will soon find that you develop a rhythmic rocking movement for kneading.

BASIC FORMING METHODS

In addition to modeling a solid lump of clay, coils, slabs, and pinch pots are extremely useful basic forming methods that can be used to build up clay sculptures.

MAKING COILS

YOU WILL NEED
MATERIALS
Clay

Long sausages or coils of clay can be used to build up the walls of pots or as reinforcements for seams where previously made clay pieces are to be joined. Coils are used to join the pinch pots that make the shell in Project 2, and to make some of the details on the horse in Project 3 (see pages 30–39). They are quick and easy to make and it only takes a little practice to roll out even coils of any thickness.

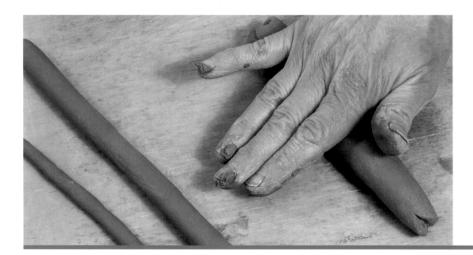

Use your hand to roll a lump of clay into a long sausage shape. Make sure you use a long, smooth rolling action with your hand and work steadily from one end of the coil to the other. Short jerky movements will result in a flattened strip of clay that will not easily roll. Practice forming coils until you are confident of making even ones. If the piece of clay you are rolling becomes too long and unwieldy, break a piece off to shorten it.

MAKING SLABS

Slabs are usually used to build forms when they are leather-hard, but can be used while still soft. There are two main techniques for making slabs, or sheets, of clay. One is to roll out a piece of clay like pastry, the other is to use a wire stretched between a pair of notched sticks to cut slices through a block of clay. You can also buy metal harps from pottery suppliers that do the same job.

YOU WILL NEED
MATERIALS
Clay

TOOLS
Scrim
Two wooden sticks
Rolling pin

ROLLING PIN METHOD

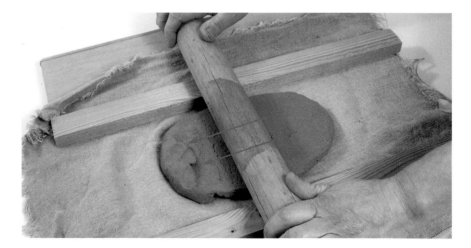

To roll out clay slabs, flatten a lump of clay onto a scrim. Use a pair of wooden sticks of the required depth as guides. Push a rolling pin over the clay to flatten and thin it down to the thickness of the guide sticks. The scrim stops the clay from sticking to the table.

NOTCHED STICK METHOD

YOU WILL NEED

MATERIALS
Clay

TOOLS
Wood saw
Two wooden
 sticks
Rolling pin
Scrim
Cutting wire
Wooden board
Newspaper

1 To make the notched sticks, saw notches in a pair of sticks at spaced intervals according to the clay thickness you require: ⅜ in. (1 cm) is a usual thickness. You could use the other end of the sticks to make wider spaces for thicker slabs or have a second pair of sticks with narrow spaces for thin slabs. The notched sticks and wire act like a cheese wire to cut slices through a large block of clay.

2 Shape a clay block to the size required and level the top using a rolling pin and a piece of scrim to prevent the pin from sticking to the clay.

3 Check the size with a template—the paper template shown here is for the body of the horse in Project 3 (see pages 34–39).

4 Hold a cutting wire at the required level on the notched sticks and cut slices from the clay block, moving the wire down a notch each time until you reach the bottom.

5 For a wide shallow block like this one you will end up with three or four slabs of clay. Carefully pick up each slab with the rolling pin, but do not use your hands because the slabs will distort and tear. Lay the slabs on boards covered with newspaper; it stops the clay sticking to the board and helps to absorb some of the clay's water.

MAKING PINCH POTS

Many small sculptural pieces can be made by joining pinched bowls to make a hollow form. The pressure of the air enclosed inside helps prevent the form collapsing when it is manipulated and altered by squeezing or beating. Although the form is simple, a little practice is required to master the technique of making pinch pots.

YOU WILL NEED

MATERIALS
Clay

TOOLS
Wooden board
Fork
Soft brush
Modeling tool

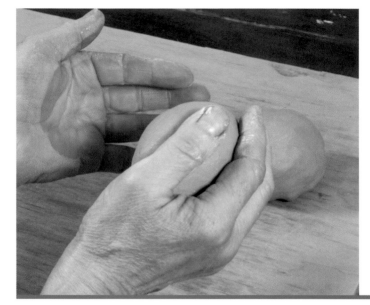

1 Weigh out a ball of clay not more than 10 oz. (300g), a size that should fit comfortably in the palm of your hand.

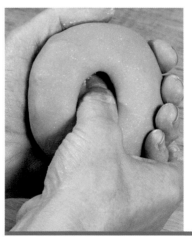

2 Holding the ball of clay cupped in one hand, make a deep dent in the center, using the thumb of the other hand.

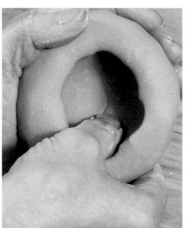

3 Begin to turn the ball of clay; at the same time, squeeze the thumb gently against the fingers to press out the sides of a shallow bowl.

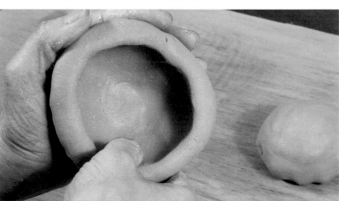

4 Continue making very small turns with a squeeze at every turn, working from the bottom to the top rim of the bowl.

TIP
When shaping a pinch pot, always work from the base up toward the rim of the bowl, otherwise the edge will thin out too soon and start to crack.

5 Leave the bowl upside down on a board. Make another bowl from a second ball of clay in exactly the same way. In order to join two pinch pots, the rim of each bowl needs to be kept fatter than the walls, so that it is sturdy enough to make a strong joint.

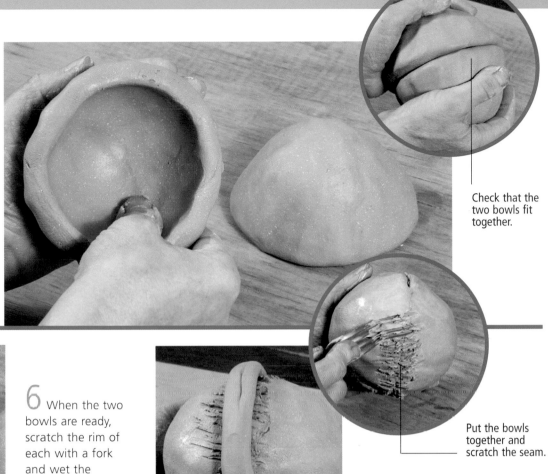

Check that the two bowls fit together.

6 When the two bowls are ready, scratch the rim of each with a fork and wet the roughened edges using a soft brush and water.

Put the bowls together and scratch the seam.

7 Put the two bowls together rim to rim and gently but firmly press them to secure the joint. Scratch over the outside seam with the fork and add a coil of soft clay to reinforce the joint.

8 Smooth the joint with fingers and a modeling tool. The sphere will keep its shape due to the pressure of the air trapped inside and can be manipulated without collapsing.

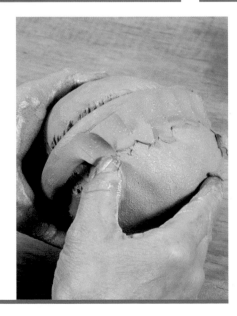

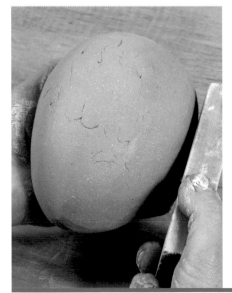

9 Smooth the surface with a modeling tool or alter the shape by beating gently with a small block of wood.

JOINING TECHNIQUES

To build up your sculpture, you will no doubt need to add pieces of clay to a basic shape. Whether the clay is newly prepared and soft or has been allowed to dry out a little will determine how you make the joint.

JOINING SOFT CLAY

YOU WILL NEED
MATERIALS
Clay

TOOLS
Fork
Soft brush
Pointed knife

When clay is soft it can be built up simply by smearing on new pieces of soft clay, as shown here. Scratching the surfaces to be joined with a fork and wetting the scratched areas can also help. When hollow forms are joined together the seam can be reinforced with a soft clay coil, as shown on page 21 with two pinch pots.

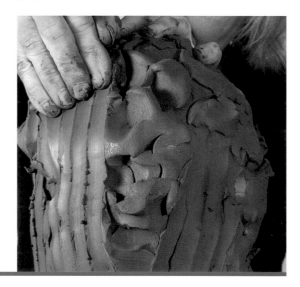

JOINING LEATHER-HARD CLAY

When clay has stiffened but is not completely dry, it is said to be leather hard. Leather-hard clay has the consistency of cheese. It can be cut with a knife but it is no longer possible to bend. Two pieces of leather-hard clay cannot be joined by smearing them together as with soft clay, so a different technique is used. This example uses the head from Project 5, and the same method is used to join the leather-hard pieces of the horse in Project 3 (see pages 46–51 and 34–39).

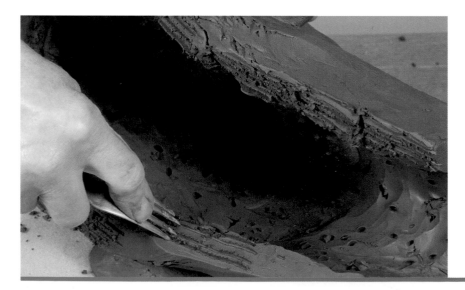

1 Scratch and roughen the two edges to be joined using an old fork. Deeply cut into the clay. The idea is to knit the roughness together, so don't be neat and tidy here.

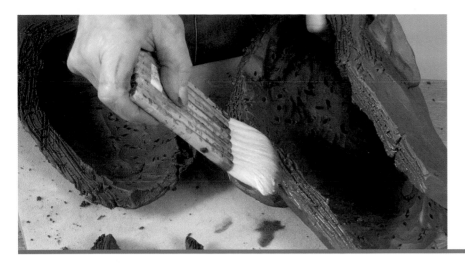

SEE ALSO
Clay Modeling
Preparing Clay, page 16
Making Coils, page 18

2 Use a soft brush to wet the two rough edges with water.

3 Press the two pieces firmly together then score across the outside of the seam with a pointed knife.

Gently press the clay coil into the seam.

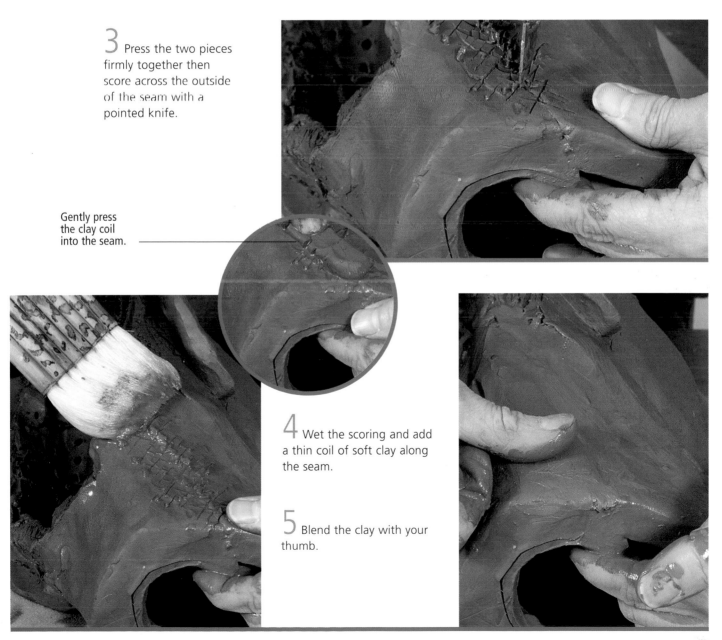

4 Wet the scoring and add a thin coil of soft clay along the seam.

5 Blend the clay with your thumb.

MAKING AN ARMATURE

An armature of a sculpture is like the skeleton of a body; it is the framework that supports the outer material. A balloon armature makes a great "skull," around which you can model the head and face. A post armature can be used to make figures.

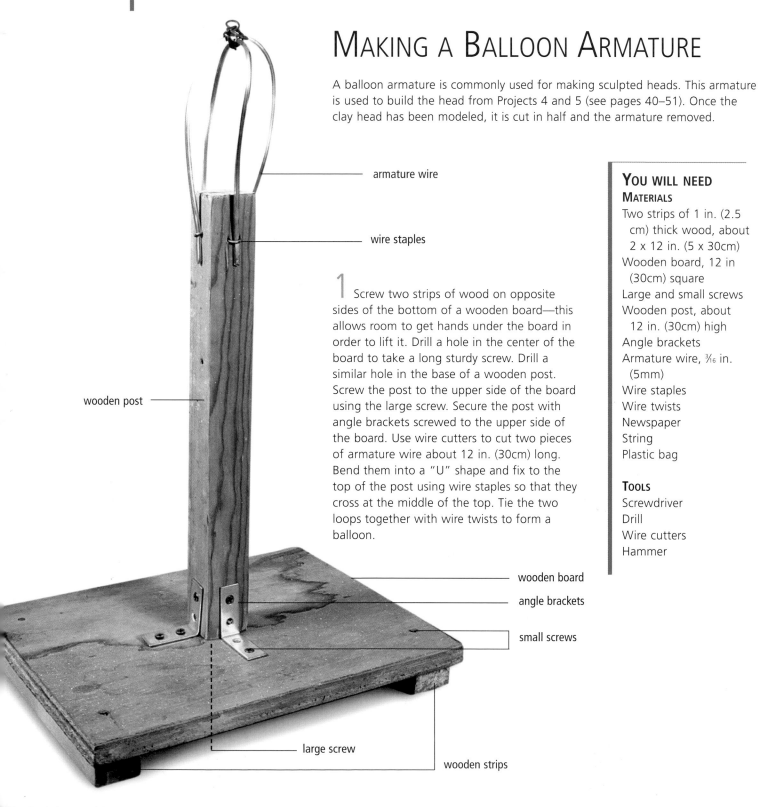

MAKING A BALLOON ARMATURE

A balloon armature is commonly used for making sculpted heads. This armature is used to build the head from Projects 4 and 5 (see pages 40–51). Once the clay head has been modeled, it is cut in half and the armature removed.

armature wire

wire staples

1 Screw two strips of wood on opposite sides of the bottom of a wooden board—this allows room to get hands under the board in order to lift it. Drill a hole in the center of the board to take a long sturdy screw. Drill a similar hole in the base of a wooden post. Screw the post to the upper side of the board using the large screw. Secure the post with angle brackets screwed to the upper side of the board. Use wire cutters to cut two pieces of armature wire about 12 in. (30cm) long. Bend them into a "U" shape and fix to the top of the post using wire staples so that they cross at the middle of the top. Tie the two loops together with wire twists to form a balloon.

wooden post

wooden board

angle brackets

small screws

large screw

wooden strips

YOU WILL NEED

MATERIALS
Two strips of 1 in. (2.5 cm) thick wood, about 2 x 12 in. (5 x 30cm)
Wooden board, 12 in (30cm) square
Large and small screws
Wooden post, about 12 in. (30cm) high
Angle brackets
Armature wire, 3/16 in. (5mm)
Wire staples
Wire twists
Newspaper
String
Plastic bag

TOOLS
Screwdriver
Drill
Wire cutters
Hammer

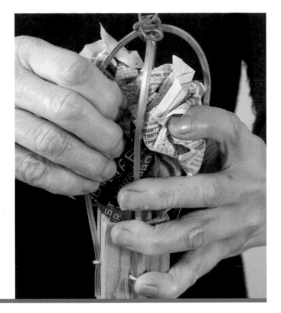

2 Stuff the balloon with newspaper.

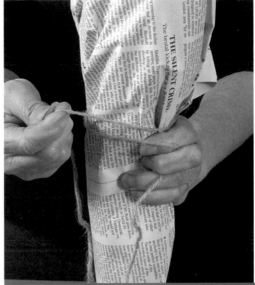

3 Wrap more newspaper around the armature to pad it and tie with string.

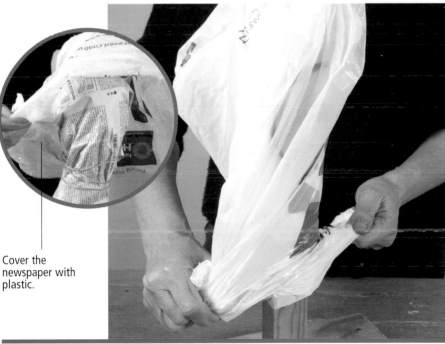

Cover the newspaper with plastic.

4 Put a plastic bag over the armature and tie tightly around the post. All this padding saves having to add a great weight of clay directly to the armature, and the plastic bag prevents the clay from sticking to the wood and wire.

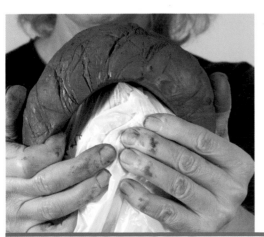

5 To start your sculpture, add thick slices of clay to the armature, blending them together with your fingers.

MAKING A POST ARMATURE

The technique for making a post armature is very similar to that for making a balloon armature, except that no armature wire is added to make the balloon. A wooden post of suitable length is attached to a base board using angle brackets and screws. This provides enough support for a simple upright form.

YOUNG BIRD: SOLID MODELING

Reproducing the form of a bird is the perfect way to introduce modeling with clay. The bird's shape is simple and compact, composed of two basic forms joined together. The body is roughly egg shaped, while the head is a small sphere that comes to a point with the beak. The wings and tail can be regarded as extensions or additions to the basic form. However, the legs are very slender and impossible to model in clay without support. In this case the support is made in the form of a plinth, onto which the legs are modeled in relief. Much of the modeling process is simply carried out with the hands and fingers, so the beginner can get used to working with clay, and because air-drying clay is used, this project does not require any expensive equipment.

When you begin modeling with clay, it is a good idea to copy something that you can pick up and look at from all angles. A Dresden porcelain bird was used as the model for this project.

Copied from a Dresden porcelain bird (see below), Young bird is modeled in air-drying clay and painted with acrylic paints.

YOU WILL NEED

MATERIALS
Air-drying clay with nylon fiber
Gloss hardener for air-drying clay
Acrylic paints

TOOLS
Wooden board
Small modeling tools
Household paintbrush
Paint palette and plastic spatula
Fine artists' brushes

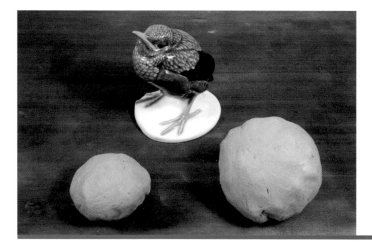

1 Measure out a 7 oz. (200 g) and a 1 lb 2 oz. (500 g) lump of air-drying clay. Using the model you are reproducing for visual reference, use your hands to pat each of the two clay lumps into a ball.

2 Flatten the smaller ball into a thick disk by patting it with your hand and place it on a wooden board. Pick up the larger ball and gently squeeze out a thick stalk from the bottom. With your fingers, smear the stalk onto the disk made from the smaller ball and make sure the clay is well blended. This will form the support for the bird.

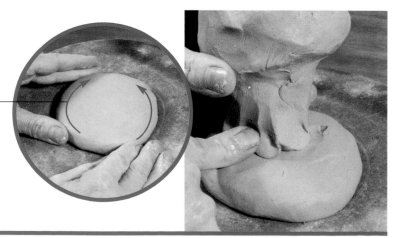

To form the base pad, rotate and pat the ball of clay flat.

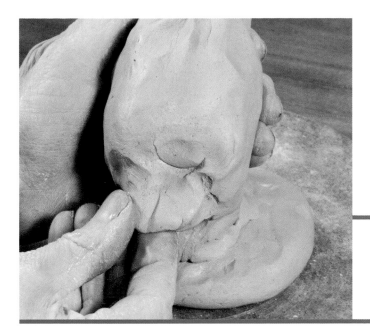

3 Start squeezing and pinching the clay to shape the bird's body and head. Pinch out the beak and tail.

Pinching out a point at the head end of the bird to form the beak.

TIP

Air-drying clay can be very soft and sticky, so if you find that your sculpture is too floppy, allow it to dry a little overnight. Alternatively, use a hair-dryer to stiffen up the supporting stalk then continue modeling the body and head.

4 It is important at this stage that the bird does not become lopsided, so draw into the clay with a pointed modeling tool to show the midline of the head and indicate where the wings will be added. At each stage, check against the model you are copying from.

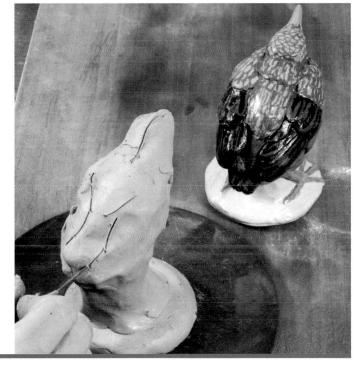

5 Now work on the details. Add small pieces of soft clay (see page 22) to the bird's body to shape the wings, carefully noting where the long feathers are, as well as the smaller, downy feathers that fluff out the shape. Use a small modeling tool to make a hole for each eye. The deep shadow of the hole will create the effect of a dark eye without any added color or paint.

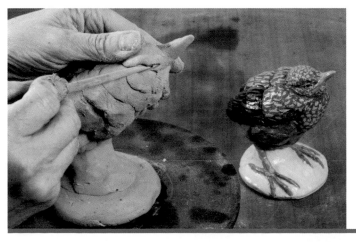

6 Build up the downy shoulders of the bird by adding more clay and continue shaping the beak and head.

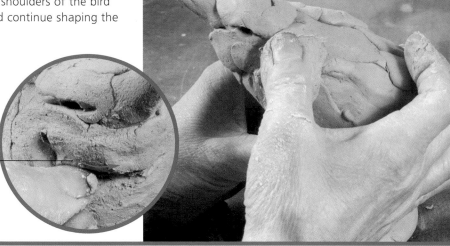

Use your thumbnail to shape the beak and head.

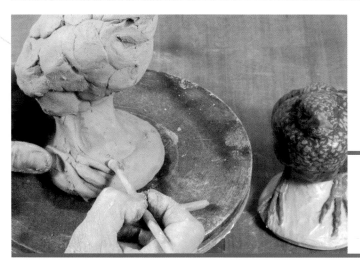

7 Once the main shape is established, add tiny coils of clay (see page 18) to the support and base to shape the legs and feet. Slim the coils and shape the legs and feet with a fine modeling tool.

Refining the claws.

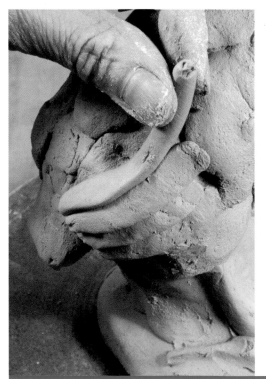

8 Add small coils to the wing ends to form the primary feathers. Overlap the coils and flatten them to form feather edges.

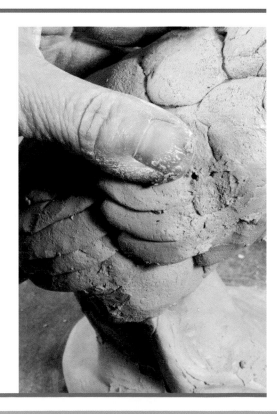

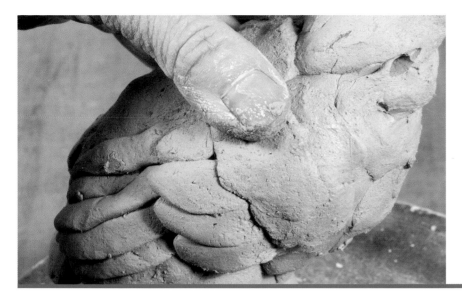

9 Create the downy feathers on the shoulder edge of the wings by adding small pads of clay. Gently press them on with your thumbs.

10 Leave the sculpture to dry out and harden for two or three days. To seal the surface with gloss hardener, pour a little of the hardener liquid into a small bowl and paint an even coat all over the bird. It will look white in the beginning, but will dry to a shiny, transparent finish.

The hardener dries to a shiny, transparent finish.

11 When the surface has dried completely, it is ready to paint. Paint the sculpture using acrylic paints of your choice (see pages 120–121).

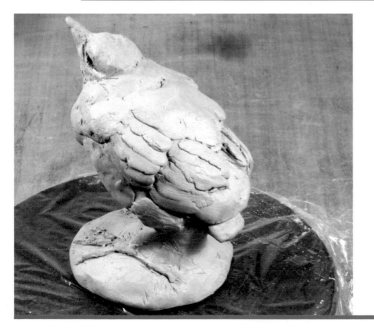

SEE ALSO
Clay Modeling
Preparing Clay, page 16
Making Coils, page 18
Joining Soft Clay, page 22

Finishing Techniques
Surface Finishes, page 120

SHELL FORM:
HOLLOW MODELING

This hollow shell is formed from a base of two joined pinch pots. A little reshaping with a wood block or spatula, followed by shaping by hand and indenting with modeling tools, transforms the original basic sphere.

The burnished shell sculpture has been sawdust fired to give it a dark smoky finish.

YOU WILL NEED

MATERIALS
Clay, white stoneware or
 semi-porcelain

TOOLS
Wooden board
Fork
3 x 2 in. (7.5 x 5 cm) block
 of wood or wooden
 spatula
Modeling tools
Newspaper
Pebble
Chamois leather

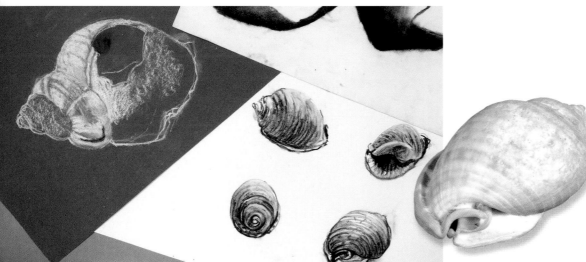

1 Use a real shell as a visual guide or draw a shell from different viewpoints to help you understand its shape and how its structure works. Weigh out two 10 oz (300 g) balls of clay. Form each ball into a pinch pot and join the two together (see page 20). Use a 3 x 2 in. (7.5 x 5 cm) block of wood or a wooden spatula to gently beat the sphere to elongate it.

2 Mark out the ends and the midline of the shell by drawing into the clay with a sharp modeling tool, and pinch out the pointed end of the shell shape.

Pinching out the tip of the shell.

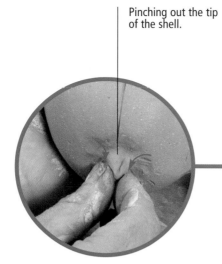

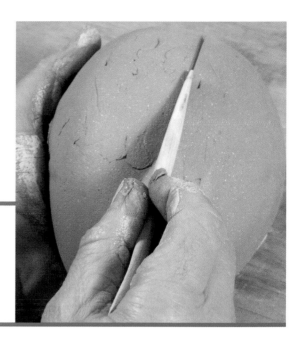

3 Use the corner edge of the block of wood or spatula to shape the spirals at the pointed end.

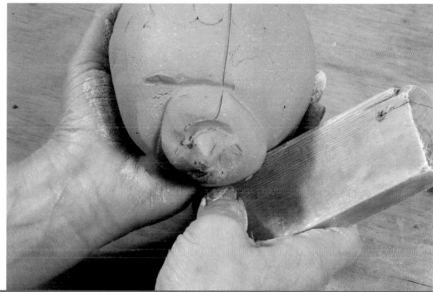

4 Pinch out the shell flanges.

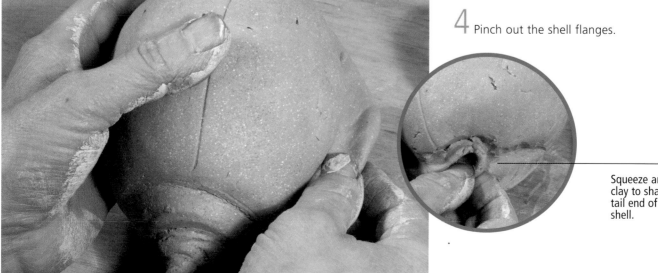

Squeeze and pinch clay to shape the tail end of the shell.

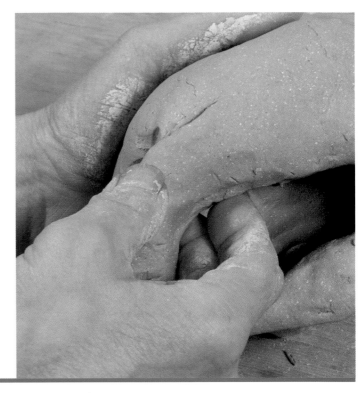

5 When the top of the shell has been formed, turn it over to start making the spiral core and hole underneath. Gradually press into the bottom, shaping the core and hollow until the thumb breaks through into the hollow interior.

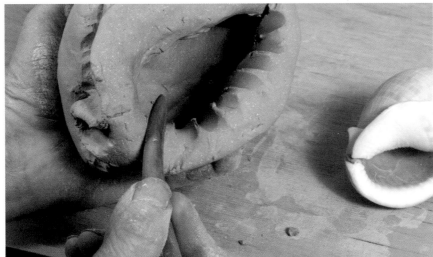

6 Form the fluted edges with a wooden modeling tool.

7 To prevent the shell from losing its shape, stuff the inside with small pieces of newspaper. Slightly overstuff the shell with extra newspaper before turning it over, so that the detail underneath does not get flattened out on the board.

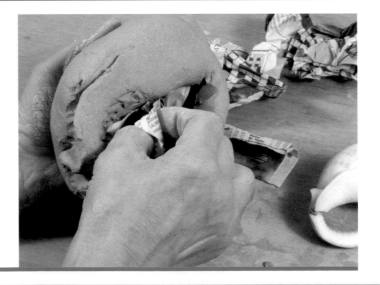

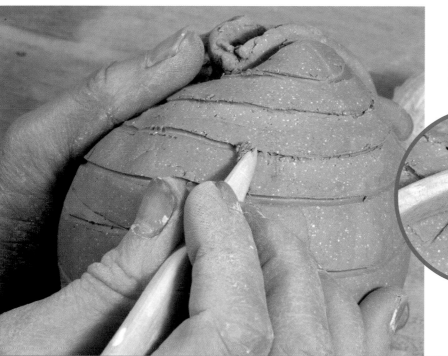

8 Use a modeling tool to mark the spiral rings on the surface of the shell and indent the ridges.

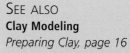

Work across the spiral ridges with a modeling tool to create indentations.

SEE ALSO
Clay Modeling
Preparing Clay, page 16
Making Pinch Pots, page 20
Sawdust Firing, page 123

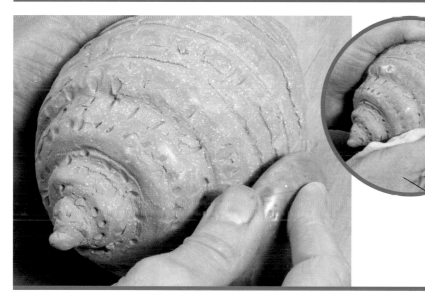

9 Leave the shell to dry to leather-hard and burnish the surface using a smooth pebble followed by a chamois leather.

Use a chamois leather to finish the burnishing process.

10 Once the burnished shell is completely dry, remove the newspaper and bisque fire to 1,796°F (980°C) to give it strength while retaining the burnish, then sawdust fire to give a dark smoky finish (see page 123).

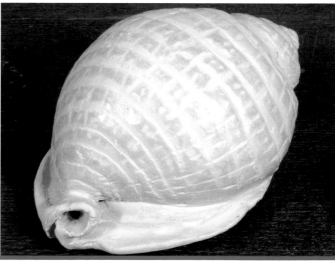

ANCIENT HORSE:
HOLLOW MODELING

This project continues from the simple hollow modeling featured in Project 2. Instead of pinch pots, the elements of the horse's anatomy are built up by rolling slabs of clay around tubular forms and then shaping them further by hand.

TIP

Any animal shapes can be determined through trial and error by rolling up and shaping pieces of clay and then cutting them open again to discover the resulting flat shape. The flat clay shape can then be copied onto paper to make a template.

YOU WILL NEED

MATERIALS

Clay, craft crank clay or other grogged clay
Decorating slips, black, brown, ochre, and white
Coarse scrim

TOOLS

Wooden board and rolling pin
Cutting sticks and wire
Newspaper
Cartridge paper, pencil, and scissors
Modeling tools
Knife
Cardboard tube, 2½ in. (6.5cm) diameter
Pipe or doweling, ⅞ in. (22mm) diameter
Foam
Fork
Soft brushes

This horse sculpture was painted with black, brown, yellow ochre, and white decorating slips, and then fired at 2,212°F (1,100°C).

1 Using the notched stick method (see page 19), create your slabs of clay, ⅝ in. (1.5cm) thick. Draw the horse template shapes onto a piece of stiff paper or cardboard. The horse body is a rectangle and the legs are tapered. Cut out the paper templates and lay them on the clay slabs. Draw around them with a pointed tool.

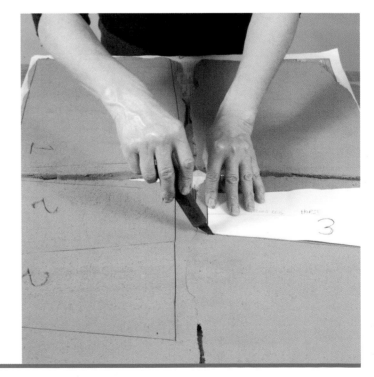

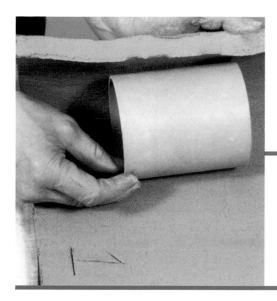

2 Use a sharp knife to cut out and label body piece Number 1. Loosely wrap the body slab around a 2½ in. (6.5 cm) tube to shape it. Stand it on its end and remove the tube.

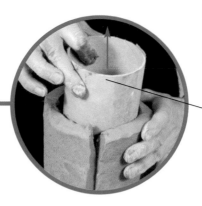

Hold the clay carefully while removing the supporting tube, taking care to retain the shape.

3 Pinch the seam together and stuff the hollow with newspaper to barrel out the belly and support the shape.

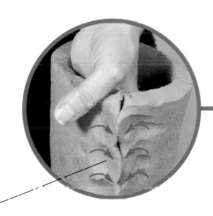

Pinching the body seam together.

4 Smooth over the seam and bend the body tube to form the saddle area of the horse's back. Curve the end where the neck will join it. Leave out overnight on a board to stiffen up.

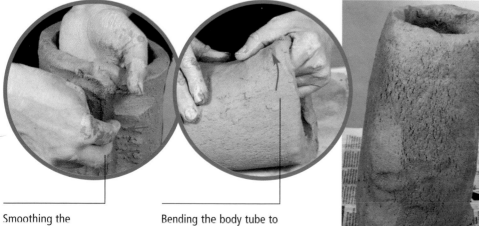

Smoothing the pinched seam.

Bending the body tube to form the saddle curve.

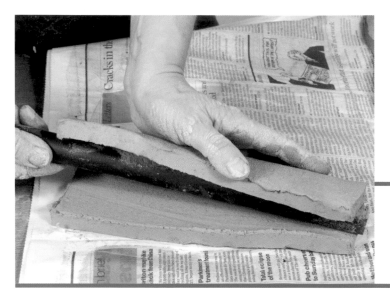

5 Cut out the leg slabs and fold them around a piece of pipe or doweling. Pinch the seam together on the lower part of the leg.

Take care not to trap the pipe when pinching the seam on the lower leg.

6 For the front legs, flatten out the top part and cut to a rounded shape to form the shoulder. For the back legs, flare out and flatten the top to create the haunch, then bend the leg to form the angle between the haunch and lower leg. Lay the legs on a piece of foam and leave to stiffen overnight.

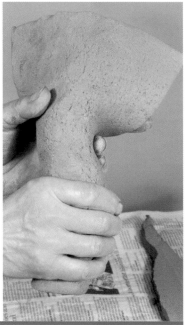

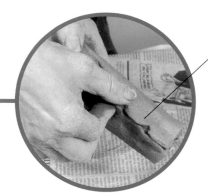

7 Cut out the head shape, fold it around a piece of newspaper, and pinch the cheek area together.

Closing up the nose end.

8 Model the nose and eye sockets with your thumb and shape the face.

Modeling the mouth.

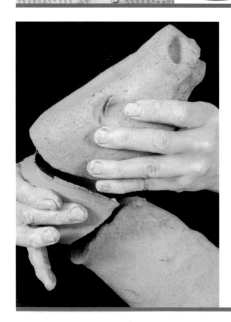

9 Cut out and fold the neck piece and the tiny extra piece that forms the top of the head. Leave these to stiffen overnight.

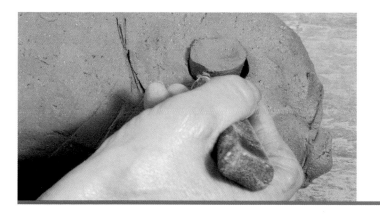

10 When all the pieces of the horse are leather hard, the parts can be joined. Place the top of a leg against the body section and mark around it with a pointed tool. Cut a small hole into the body in the center of the marked area—this is to ensure a continuous air channel throughout the hollow inside of the sculpture to prevent it exploding in the kiln.

11 Scratch around the line of the mark and the top of the leg with a fork, wet the scratched edges, and join the leg to the body (see page 21).

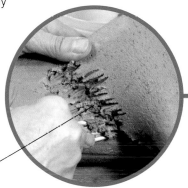

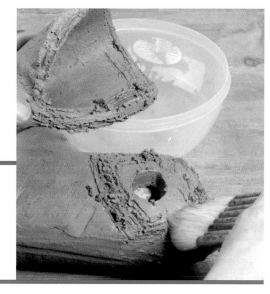

Score thoroughly across the seam to make a good join.

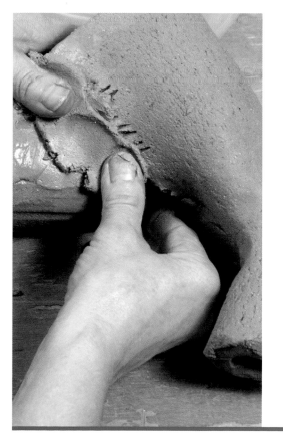

12 Reinforce the seam with a coil of soft clay and round off the leg tops with more soft clay.

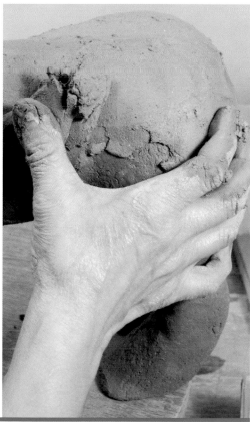

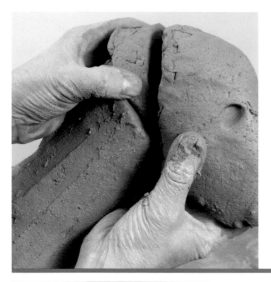

13 Stand the horse up and join the neck and head pieces in the same way. Check the position of the head and, if necessary, cut a small slice from the back of the head or neck piece to create the right pose when the horse is assembled.

OPTIONAL BASE

At this stage, the sculpture can be joined to a clay base, although the horse should be able to stand alone on its sturdy legs. To make the base, cut or roll out a 1½ in. (4 cm) thick slab of clay. Cut this into a 10 x 12 in. (25 x 30cm) slab. Allow the slab to dry to the leather-hard stage. Stand the horse on the base and draw around the feet with a pointed tool. Remove the horse and cut a hole in the base in the center of each mark to create the air channel. Score and wet the marked areas and the underside of the feet and firmly attach the horse. Secure the joints with a small coil of clay.

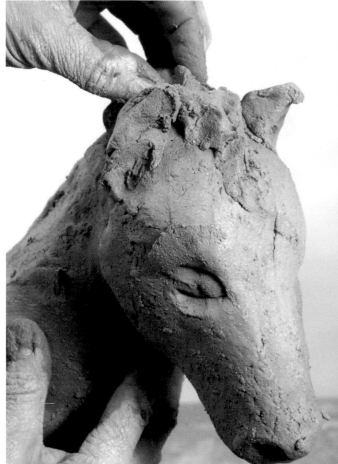

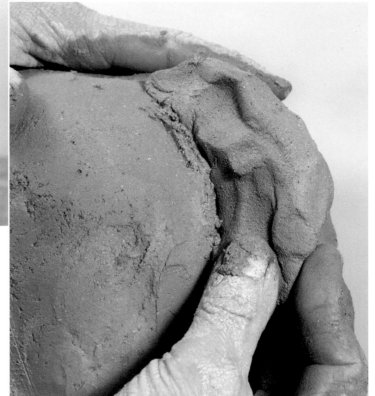

14 Now add the details: ears, mane, and tail. Scratch and wet the leather-hard clay along the neck to attach a soft coil of clay to form the mane. Comb this into shape with a modeling tool. Attach a piece of soft clay in the same way to make the tail.

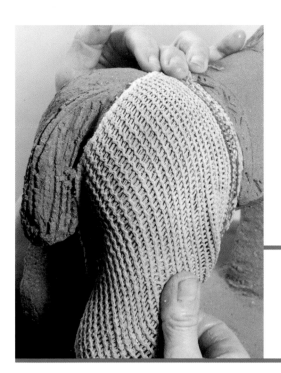

15 Add fine coils to make the saddle border and bridle. Finally, create the texture of the horse's hide by placing a piece of damp, coarse scrim on the body and rub with fingers.

SEE ALSO
Clay Modeling
Preparing Clay, page 16
Making Coils, page 18
Making Slabs, page 18
*Joining Leather-Hard Clay,
 page 22*

Finishing Techniques
Firing Clay, page 122

Peeling back the damp cloth to reveal texture.

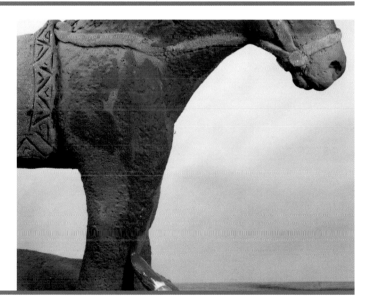

16 When the horse is nearly dry, paint it with decorating slips. First paint on a coat of black slip, then roughly paint on a layer of brown slip, more on the body and less on the mane and tail, to give the impression of a brown horse with dark mane and tail.

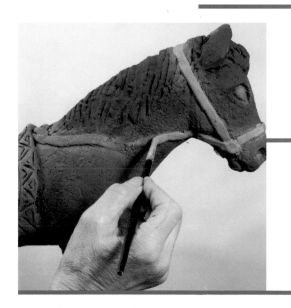

17 Highlight the bridle with a yellow ochre slip and create saddle patterns with your own choice of black, brown, ochre, and white slip. Fire to 1,832°F (1,000°C) to finish (see pages 122–123).

Paint details and patterns on saddle using brown, yellow ochre, and white slips.

HEAD OF A YOUTH:
SOLID MODELING ON A BALLOON ARMATURE

This project involves working from an original portrait sculpture as a reference. A real person, such as a family member, could be used as a sitter, or you could work from photographs, occasionally checking proportions and details with your life model. The aim of this project is to show the technique of solid clay modeling on a balloon armature, as well as developing observation and understanding the human head form.

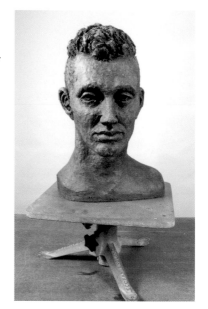

Copied from an original sculpture (see right), this head of a youth is fired terracotta, polished with red tile polish and mounted on a wood block.

YOU WILL NEED
MATERIALS
Clay, terracotta
Fine scrim

TOOLS
Balloon armature
 (see page 24)
Turntable
Modeling tools
Calipers
Two matchsticks

1 Position a balloon armature (see page 24) on a turntable for ease of turning the sculpture. Begin adding thick slices of clay to cover the armature.

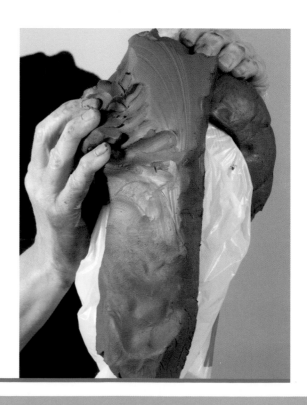

2 Blend the slabs together with your fingers.

Pat the clay firmly onto the armature.

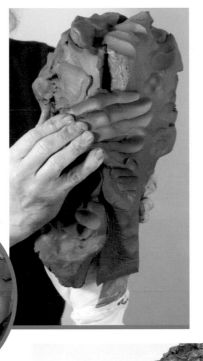

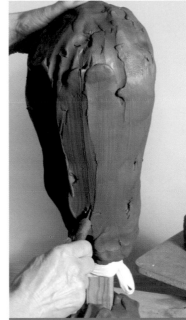

3 With a modeling tool or knife, mark out the midline of the face.

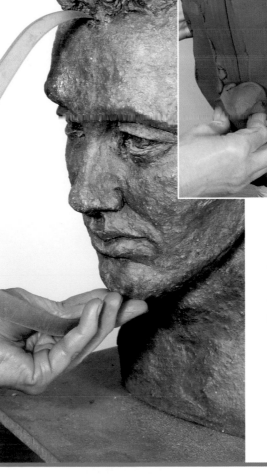

SEE ALSO
Clay Modeling
Preparing Clay, page 16
Making Coils, page 18
Joining Soft Clay, page 22
Making a Balloon
 Armature, page 24

4 Use calipers to take a measurement from the model (in this case the original sculpture) between the chin and point of hairline on the forehead and add a piece of clay to the sculpture for the chin, in line with the caliper measurement.

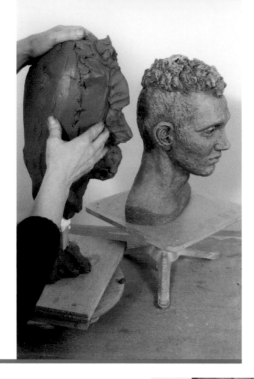

5 Build up a profile view of nose, lips, and chin.

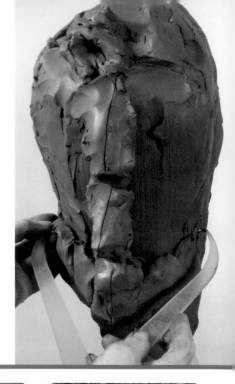

6 Again use calipers to check the width of ear holes on your model and mark the position of these with something durable, such as a pair of matchsticks. You will be able to feel these as a permanent reference even if they get covered with clay from time to time.

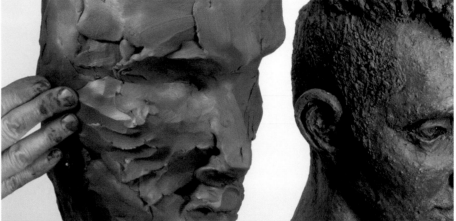

7 With your fingers and thumbs, work around the head. Shape the eye sockets, pad the cheeks, and build the mound of muscle that forms the mouth area.

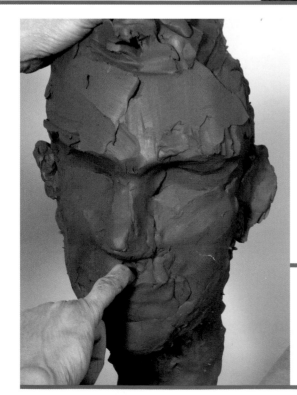

8 Add clay for the hair and ears and shape the nose and lips. Add some small coils of clay to make the lines at the side of the mouth and roll the clay into the cheek area. Mark the little dent on the upper lip area below the nose using your little finger or a rounded modeling tool.

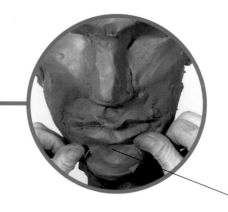

Shaping chin and lower lip.

9 Push a flat modeling tool deep into the mouth to mark the parting of the lips. Roll the modeling tool to push clay up and back to form the upper lip. Roll the tool down to form the lower lip.

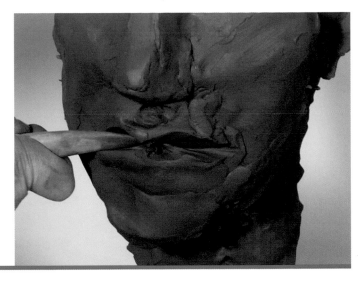

10 Make balls of clay for the eyes and place them into the eye sockets.

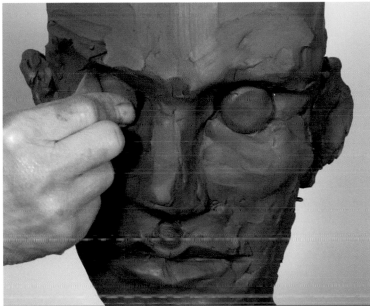

11 Form the eyelids from small coils of clay and smooth them carefully over the eyeballs.

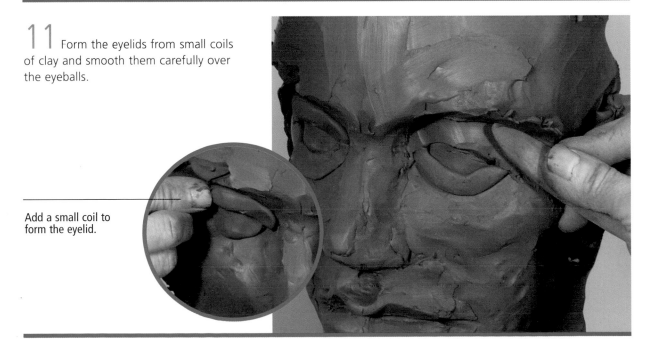

Add a small coil to form the eyelid.

12 Refine the eyelids using small modeling tools. Put a tiny round pad of clay onto the eyeball to make the iris and then stir the center of the eye with a small tool to create the pupil. The dark shadow of the hole in the sculpture recreates the effect of the black pupil in the center of a living eye.

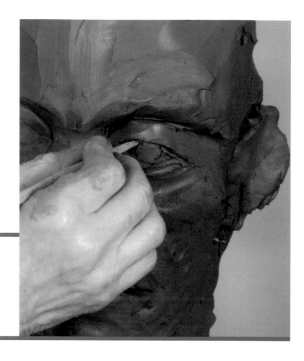

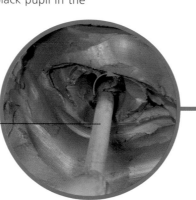

Use a small modeling tool to create the pupil of the eye.

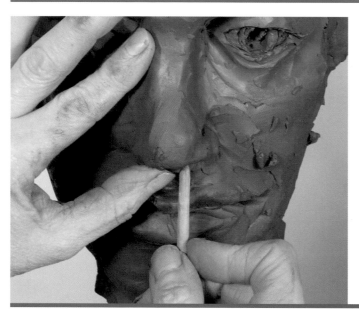

13 Work on the nose, observing the pad of cartilage that forms the end of the nose and add a little clay to shape it. Add some beads of clay for the nostrils, taking care not to make them too large.

TIP

Take extra care to ensure that the eyes are looking in the same direction. You do not want your sculpture to squint. This is a detailed stage of the modeling process so be prepared to spend time on it and rework areas where necessary.

14 Continue to work around the sculpture, refining and modeling the details. Shape the large tendons in the neck and define the Adam's apple area. Remember to look up from below and check the shape of the nostril holes and under the jaw.

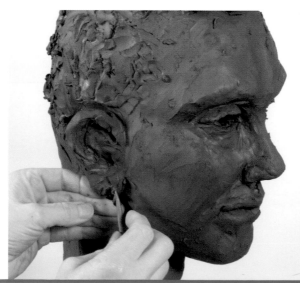

15 Once you are satisfied with the modeling of the sculpture, you can refine the skin surface to remove finger or tool marks. Marks may not be evenly distributed over the face and will reflect light in varying ways, which could distract from the overall form of the sculpture. The skin on the face has a smooth texture that contrasts with the roughness of the hair. To ensure that the skin of the face reflects light consistently, it can be evened out by imprinting a very fine texture. Apply a square of damp, fine scrim to the face, starting near the hairline. Rub until clay appears through the fabric.

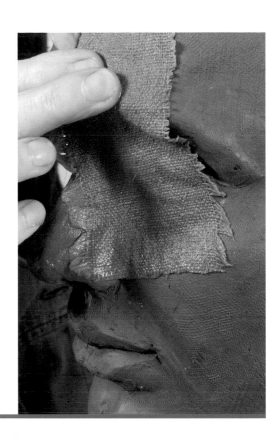

16 Peel back the scrim to show the fine cloth texture. Repeat this process over the whole face, including the nose, under the chin, and on the neck.

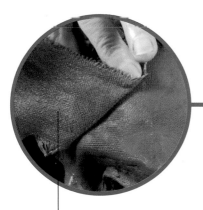

Pull back the damp cloth to reveal the texture.

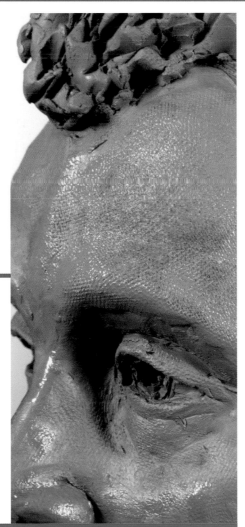

17 When you are happy with the finished texture, leave the sculpture to stiffen to the leather-hard stage.

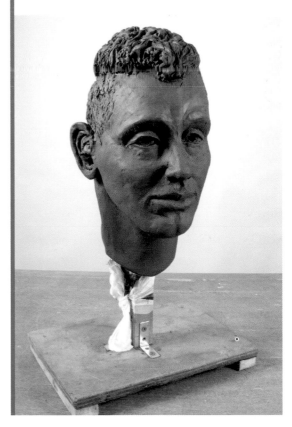

HEAD OF A YOUTH:
HOLLOWING, FINISHING, AND MOUNTING

This stage continues on from Project 4. You will learn how to remove a clay sculpture from an armature and prepare it for firing. After firing, the sculpture is mounted on a wood block.

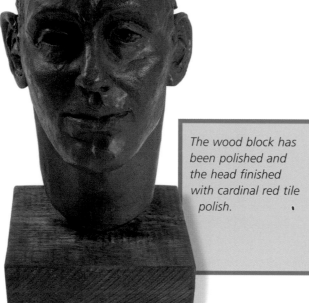

The wood block has been polished and the head finished with cardinal red tile polish.

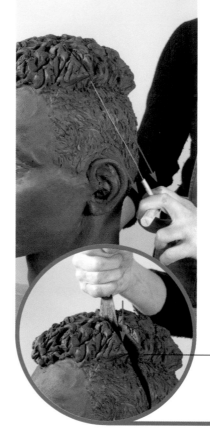

YOU WILL NEED

MATERIALS
Head of a Youth sculpture
 (see pages 40–45)
Fine scrim

TOOLS
Cutting wire
Knife
Plastic-coated board
Upholstery foam or old
 cushion
Wire loop tool
Pointed modeling tool
Fork
Soft brush

FOR THE STAND
Drill
Wood block
Pipe, ⅞ in. (22mm)
 diameter
Car body filler
Strong adhesive

1 Stand the leather-hard sculpture (see pages 40–45) on a table. Using cutting wire, cut through the back of the head from just behind the hairline, above the forehead, down behind the ears, and finish at the nape of the neck. Cutting through the back of the head avoids damaging intricate details, such as the eyes, and the hair and back of the neck are relatively easy to remodel if necessary. The wire may not pull all the way through because of the armature inside, so finish cutting with a stripping knife.

Use a knife to remove the back of the head from the armature.

2 Pull the back of the head away from the front, supporting the front with the other hand to ensure that the sculpture does not topple forward due to the now unbalanced weight.

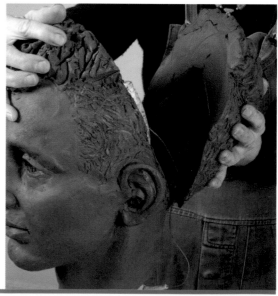

3 Place the back piece, cut-side down, on a piece of upholstery foam, supported by a board, and start removing the armature packing through the hole in the back of the head.

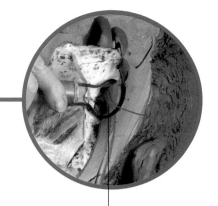

Use a wire loop tool to remove clay and help release the armature.

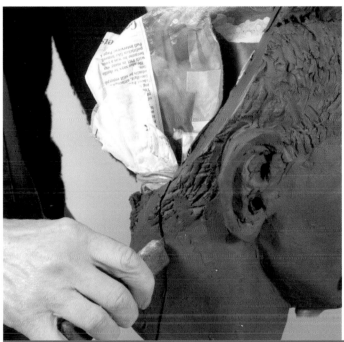

4 Squeeze the armature balloon to narrow it. If possible, allow the balloon to pass through the neck hole and lift the rest of the head and neck off the post. If this is difficult, due to the sculpture being unstable or the neck firmly adhering to the armature post, cut off the back of the neck with the knife and lay it cut-side down on the board.

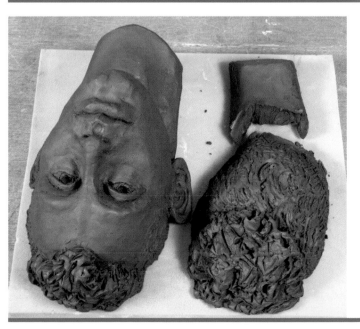

5 Lay the front of the sculpture cut-side down on some upholstery foam or an old cushion on the board. At this stage, you will have either two or three pieces to be rejoined once you have hollowed the sculpture.

SEE ALSO
Clay Modeling
Making Coils, page 18
Joining Soft Clay, page 22
*Joining Leather-Hard Clay,
 page 22*
Project 4, page 40

Finishing Techniques
Firing Clay, page 122
Glazing, page 124

TIP
Use a piece of upholstery foam to pad the sculpture and protect features from damage while scooping out clay from the inside.

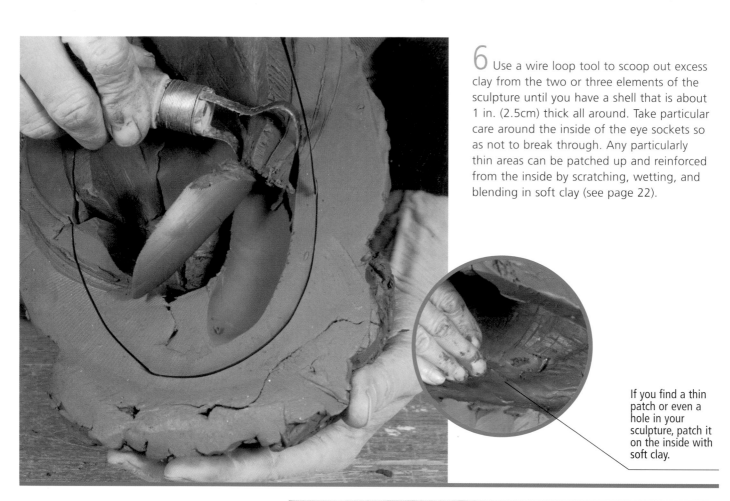

6 Use a wire loop tool to scoop out excess clay from the two or three elements of the sculpture until you have a shell that is about 1 in. (2.5cm) thick all around. Take particular care around the inside of the eye sockets so as not to break through. Any particularly thin areas can be patched up and reinforced from the inside by scratching, wetting, and blending in soft clay (see page 22).

If you find a thin patch or even a hole in your sculpture, patch it on the inside with soft clay.

7 The inside of the nose and chin will probably remain quite thick, so it is advisable to stab all over the inside of the sculpture pieces with a pointed tool to create air channels, thus reducing the risk of the sculpture exploding in the kiln.

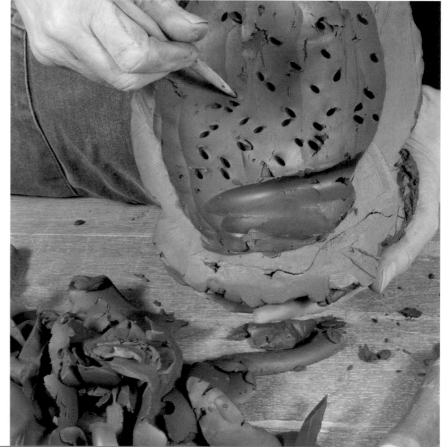

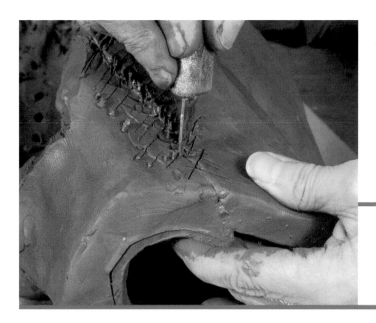

8 If you cut away the neck in Step 4, reattach it to the front of the head by scratching and wetting the leather-hard seam edge (see page 23), keeping the head supported on the foam.

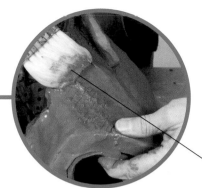

Wet the scored seam, then blend in a small coil all around it.

9 Scratch and wet the seam edge where the back of the head will join the front. Place the back of the sculpture on top of the front and carefully press the two halves together. Scratch across the seam, wet, and blend in a coil all around it.

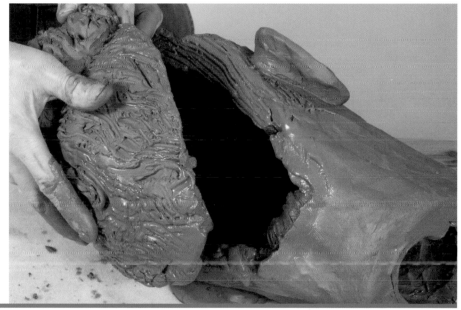

10 Touch up any damaged detail, remodeling hair, smoothing in the neck, and applying damp fine scrim to the skin surface.

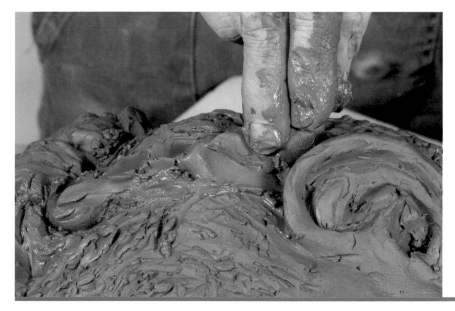

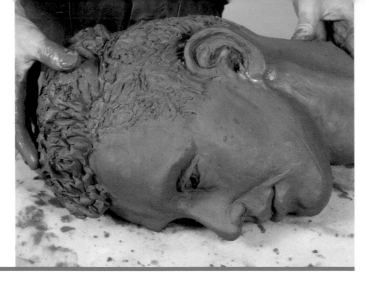

11 Leave the finished sculpture to dry completely on a cushion or foam before firing. Drying may take two or three weeks. Fire to 1,832° F (1,000°C) very slowly (see pages 122–123).

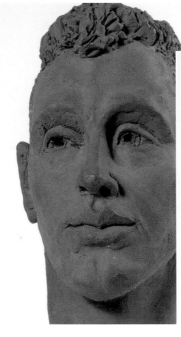

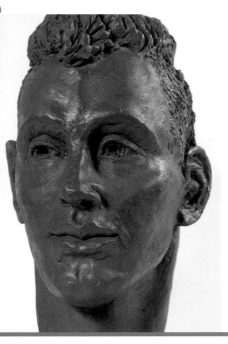

12 After firing, prominent features may appear darker than recessed areas. The iron in the clay has been worked to the surface by the action of hands and modeling tools, which darkens the areas such as the nose and cheeks. To bring back the three-dimensional qualities of the sculpture, some color should be applied. Red tile polish gives an excellent finish to smooth terracotta clay. Apply generously with a stiff brush, working it well into every fine line and groove. Allow to dry and then buff to a good sheen with a soft shoe brush.

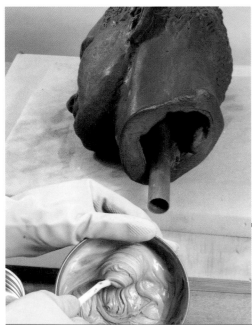

13 To mount the head on a thick block of wood, use a piece of pipe as the supporting post. Drill a ⅞ in. (22mm) diameter hole about 3 in. (7.5cm) deep in a suitable block of wood. Cut a piece of ⅞ in. (22mm) pipe to about 12 in. (30cm) long. Lay the fired head on its side on a piece of foam and fill the neck opening inside with a generous pad of car body filler.

Apply car body filler to the inside of the neck. Build up a good pad and then insert the pipe.

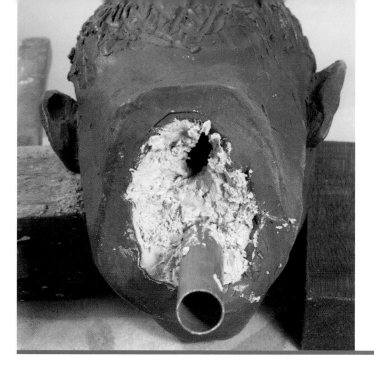

14 Lay the pipe on the filler, pushing it into the head hollow but leaving 3 in. (7.5cm) extending out. Make sure that the pipe is horizontal, or suitably placed, so that the sculpture will be in the correct vertical position once it is mounted.

15 Let this layer of filler set a while, then add more filler to secure the pipe and fill in the bottom of the neck. Leave the filler for about an hour to set hard.

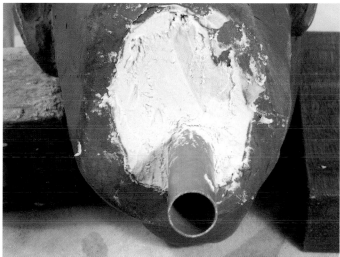

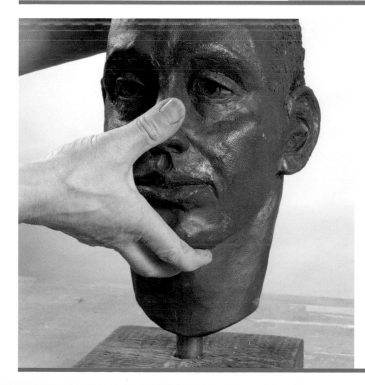

16 Place strong adhesive on the pipe end and in the hole in the wood block. Insert the pipe extension into the block to fix the head.

MOLDING AND CASTING

MANY SCULPTURES ARE first modeled in clay and then cast in a more durable material. Plaster is the main material used for making the mold. It is mixed as a liquid that flows into every detail of the clay model and then sets hard. Plaster molds can be used to make repeats in clay, as shown in Projects 6 and 8 (see pages 58–61 and 68–73), or as the basis for casting in a strong material such as very high-density plaster or cement fondue, as in Projects 7 and 9 (see pages 62–67 and 74–79). Two types of molds are shown in this section of the book: Reusable molds for making repeats of simplified forms and waste molds where the complexities of the form mean that the mold has to be broken to release the cast.

TOOLS AND EQUIPMENT

Apart from the tools used to make the clay model (see pages 14–15), and bowls for mixing the plaster, you will require little equipment for making plaster molds. Some useful tools include a stripping knife, wire brush, and fine pointed tools for cleaning up the casts.

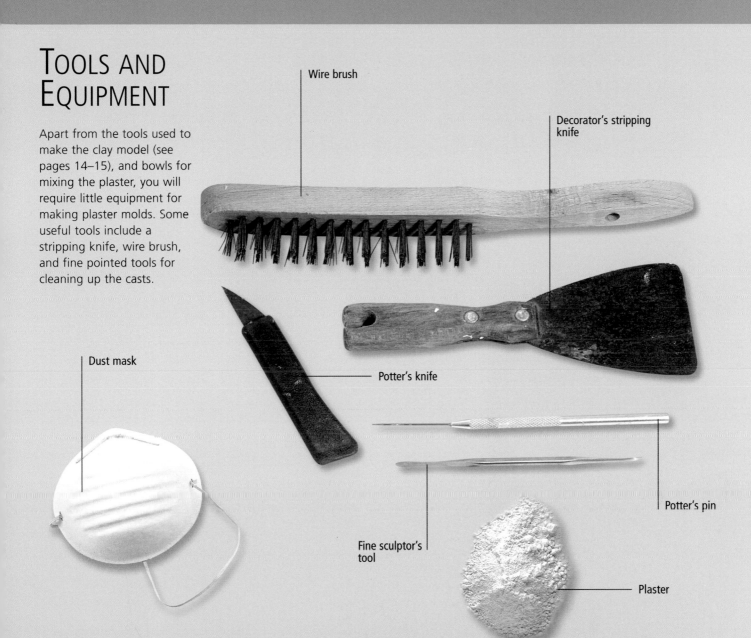

Wire brush

Decorator's stripping knife

Dust mask

Potter's knife

Potter's pin

Fine sculptor's tool

Plaster

WORKING WITH PLASTER

Plaster is more difficult to work with than clay because, before it sets, it is predominately a fluid material. In its liquid state it can be poured onto a clay sculpture to make a mold. For direct building, it has to be applied to an armature because it cannot support itself until it has set. Once plaster has set it can be carved and filed into shape.

MIXING PLASTER

Mixing plaster by eye in this way will serve for general purposes, but some processes require the water-to-plaster ratio to be more exact. In this case, the plaster should be weighed and added to the correct volume of water, following the manufacturer's instructions. Project 7 (see pages 62–67) uses a specialist plaster that must be mixed in this way.

YOU WILL NEED
MATERIALS
Plaster
Water

TOOLS
Plastic bowl
Dust mask
Scoop
Spoon or stick

TIPS
- Plaster should always be added to water and allowed to soak before stirring.
- Plaster is very messy, no matter how tidy and clean you are. Therefore, it is a good idea to cover your work table with a plastic sheet.
- Never pour plaster down the sink, because it will eventually block the drain. Instead, keep a bucket of water beside you so that you can rinse your hands and tools as you work. When you have finished working, pour out the excess water in the bucket, then throw away the plaster sludge left at the bottom.
- It is a good idea to mix plaster in flexible plastic bowls. Any surplus plaster can then be left to set in the bowl and will be relatively easy to crack out.

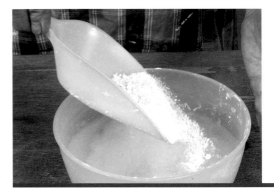

1 Pour water into a clean, flexible, plastic bowl, allowing space for the added plaster. Wearing a dust mask, use a scoop to sprinkle the plaster carefully into the water.

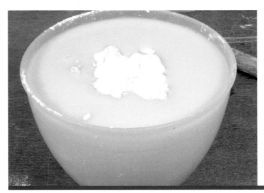

2 Continue pouring in the dry plaster until it forms a good island.

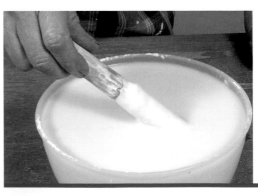

3 As soon as the island of dry plaster has absorbed water and become damp, stir it well with a stick or spoon. At this point, the chemical reaction between the plaster and water begins, which will lead to the setting point. Leave the well-stirred mix to stand for about five minutes before pouring it into the mold, flicking it onto a sculpture, or using it to build up scrim or cloth.

SAFETY
- Always wear a dust mask when working with dry plaster.
- If you have sensitive skin, use a barrier cream on your hands when handling plaster.

Making a Mold with a Clay Wall

A simple mold can be made by building a clay wall around the model and pouring liquid plaster over it and into the gap between it and the wall. The plaster flows into all the details and sets hard. The mold can then be used either to cast the sculpture in another material or to make repeats of the original in clay.

The following technique shows how to make a mold of the relief panel that is featured in Project 6 (see pages 58–61).

You will need

Materials
Clay, economical variety, including a clay original left to stiffen overnight
Plaster
Water
Scrim

Tools
Plastic-coated board
Soft brush
Plastic bowl
Dust mask
Scoop
Spoon or stick
Stripping knife

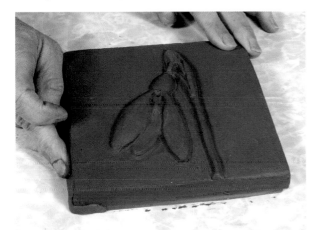

1 Place the clay original on a smooth surface, such as a piece of glass or, as here, a plastic-coated board. Graft it on with a very thin coil of clay and seal it in with a brush and water.

See also
Clay Modeling
Preparing Clay, page 16
Making Coils, page 18
Making Pinch Pots, page 20
Joining Techniques, page 22

Molding and Casting
Mixing Plaster, page 54

2 Roll out some thick coils of clay to make a clay wall for the mold and pat the coils flat. Stand the flattened coils on their edge about ½ in. (1.5cm) away from the clay original to form a wall around it. Fix the clay wall securely to the plastic, making sure that the corners are well joined. Add a thicker coil around the outside to support the wall and seal it well.

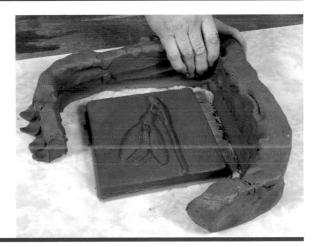

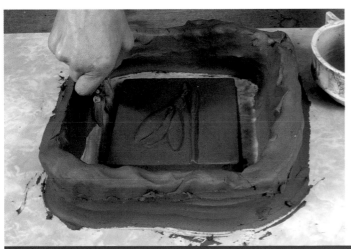

3 Make a clay wash by brushing a small pinch bowl (see page 21) with water, then paint the clay slip onto the plastic surrounding the sculpture. The clay wash will help to release the set plaster from the board in Step 8. You are now ready to pour your plaster mold.

4 Wearing a dust mask, mix the plaster (see page 54) and pour the liquid over and around the modeled tile. Jiggle the board to make sure that the whole relief is covered and that any air bubbles in the liquid plaster rise to the surface. If bubbles remain trapped against the surface of the sculpture, the mold will have holes in it that will spoil the details.

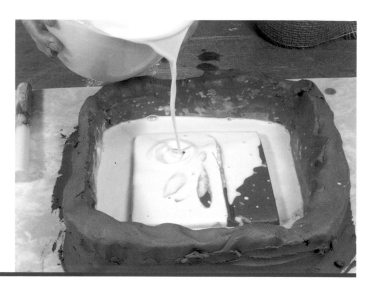

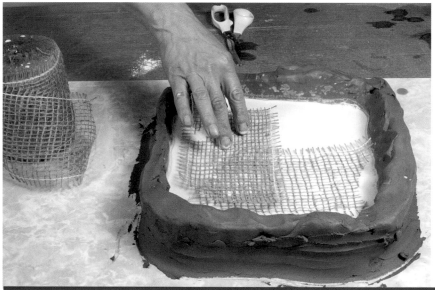

5 If the mold is to be used for repeats, as in Project 6 (see pages 58–61), it should be strengthened with scrim. Press a few pieces of coarse scrim into the surface of the creamy plaster, and then finish filling the clay wall with plaster. You do not need to use scrim if you are making a waste mold (see Project 7, pages 62–67).

6 After about 20 minutes, the plaster will heat up as part of the chemical reaction with water. When it has cooled down again it is safe to remove the clay wall from around the mold.

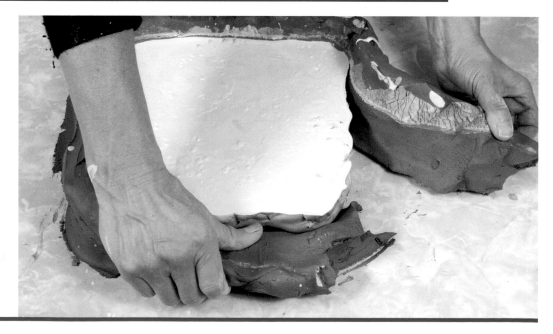

7 Shave off the sharp edges of the mold with a stripping knife. This will prevent unwanted chipping.

8 Carefully insert the stripping knife under the edge of the mold and lift it away from the board.

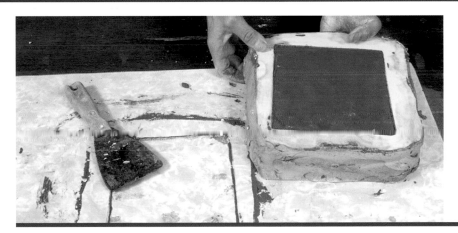

9 If you have made a reusable mold, let it dry out for 24 hours and remove the original clay sculpture. Let the mold dry out completely before use. If you have made a waste mold, clean out the clay straight away and use the mold while it is still wet.

UNDERCUTS

If you are making a reusable mold it is very important to avoid making any undercuts on the original. Undercuts are areas of an original where liquid plaster can flow around or underneath raised features in such a way that it becomes hooked in and trapped. If plaster does get hooked in undercuts, delicate pieces of the mold may break when you remove the original, or you may find that you cannot remove the original in one piece. Undercut molds can also not be used for making repeats because soft clay cannot be pressed into the inaccessible undercuts.

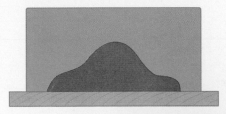

Smooth shape with no undercutting.

Difficult shape with undercutting.

SNOWDROP:
MAKING A REUSABLE MOLD

This simple flower form demonstrates how to make a shallow relief and cast a mold that can be used to make numerous repeats in clay, which can then be glazed and finished in different colors. You will learn how to transfer a picture onto a flat slab of clay and then model the relief without undercuts so that you can make a reusable mold.

Snowdrop relief, made in stoneware clay and finished with a matte green glaze.

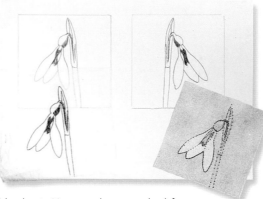

YOU WILL NEED
MATERIALS
Clay (economical variety for modeling and semi-porcelain and stoneware clays for casting)
Plaster
Water
Scrim
Glaze

TOOLS
Wooden board and rolling pin
Cutting sticks and wire
Knife
Modeling tools
Soft brush
Wire loop tool
Plastic-coated board
Plastic bowl
Dust mask
Scoop
Spoon or stick
Stripping knife
Plastic ruler or wooden straight edge
Chamois leather
Glaze brush

1 Start by choosing a picture of a flower. A simple smooth flower form such as a daffodil or tulip would be best. Here we have worked from a picture of a snowdrop. You can use enlarged photographs, photocopies, or drawings in which the edges of the shape are clear and easily seen. Make several copies, one or two as reference and one to use to transfer the image to the clay.

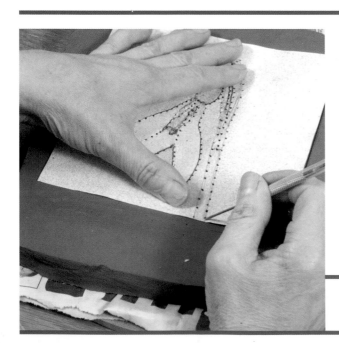

2 Cut or roll out a slab of clay about ⅝ in. (1.5cm) thick (see page 18). Mark out a square or rectangle to fit your image—this one is 6 in. (15cm) square. Lay the photocopy or drawing onto the square and prick through the image with a sharp point to transfer the motif. Allow the clay panel to stiffen overnight so that you do not squash it out of shape when adding clay to build up the relief.

Peel back the paper to reveal the design pricked into the clay.

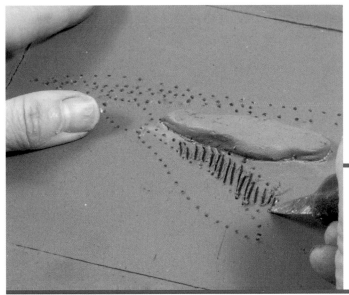

3 Shape small pieces of soft clay to form the petals and stem. Scratch and wet the panel where you want to add the extra elements and carefully model the parts of the flower onto the tile (see page 22).

Wet the scoring before adding soft clay.

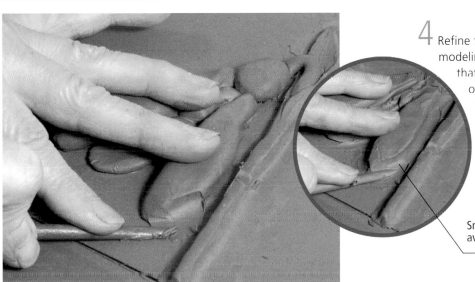

4 Refine the modeling and detail with tiny modeling tools and check carefully to ensure that there are no undercuts by working outward from the top of the petal onto the background panel.

Smooth the edges to avoid undercuts.

UNDERCUTS
You will not be able to use an undercut mold for making repeats because soft clay cannot be pressed into the inaccessible undercuts (see page 57).

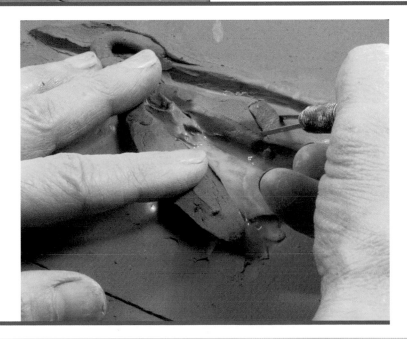

5 As the clay stiffens, further modeling can be carried out by shaving with a small wire loop tool.

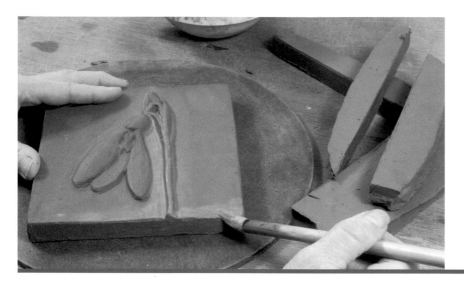

6 When you have completed the modeling, soften the edges of the motif and the panel with a brush and water.

7 Leave the panel to stiffen overnight before fixing it to a plastic-coated board ready for casting.

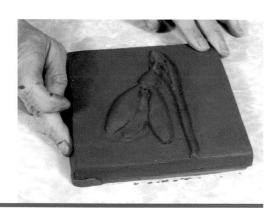

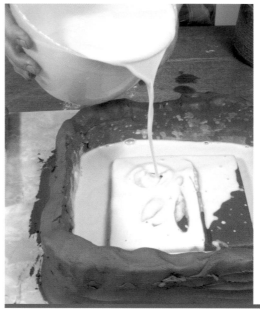

8 Build a clay wall around the panel and, wearing a dust mask, mix and pour on plaster to cast a reusable mold (see page 55). Leave the plaster to heat up and then cool down and harden; this will take at least an hour.

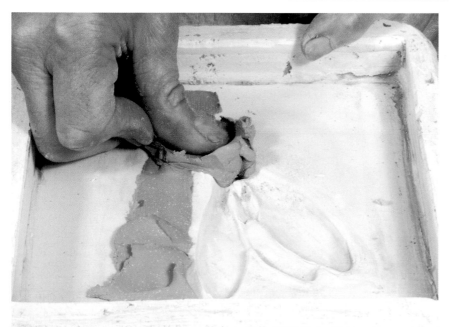

9 To make a cast of the flower, fill the mold with soft clay such as a semi-porcelain mix. Start by pressing the clay into the details of the relief.

REMINDER
Remember that we are making a reusable mold so the plaster must be left to dry out completely.

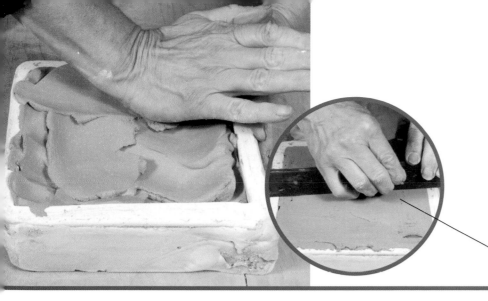

10 Continue filling the mold, making sure the clay is pressed into all the corners. When finished, level off the excess clay with a plastic ruler or a wooden straight edge.

Level off the excess clay with a straight-edged tool.

11 Allow the clay to dry to leather-hard and shrink away from the sides of the mold. Invert the mold over a board and shake gently. The cast relief should come out cleanly.

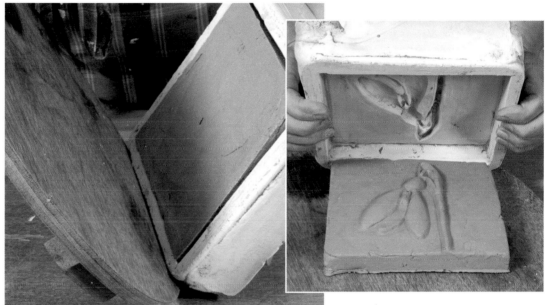

12 Smooth any untidy edges with a modeling tool and finish with a piece of wet chamois leather. Store to dry out completely before brushing on glaze and firing (see pages 124–125).

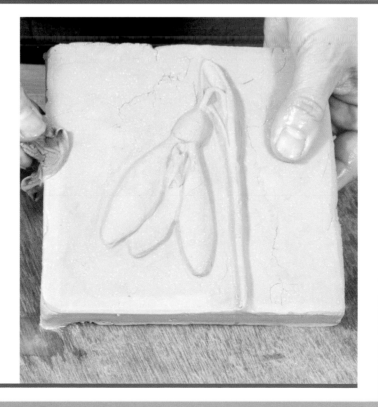

SEE ALSO
Clay Modeling
Preparing Clay, page 16
Making Slabs, page 18
Joining Soft Clay, page 22

Molding and Casting
Mixing Plaster, page 54
Making a Mold with a Clay Wall, page 55

Finishing Techniques
Firing Clay, page 122
Glazing, page 124

GROUP OF FIGURES:
MAKING A WASTE MOLD

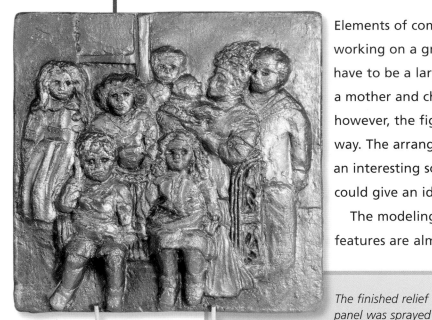

Elements of composition are the main consideration when working on a group of figures. The composition does not have to be a large group: perhaps just two figures, such as a mother and child, or a small family group. In all cases, however, the figures should relate to one another in some way. The arrangement of the figures is also vital to producing an interesting scene, and elements of the background scenery could give an idea of context to tell a story about the sitters.

The modeling of this panel is in high relief, where some features are almost completely in the round, while other background areas are in very low or shallow relief. To obtain detail, it is impossible to avoid undercuts, so this project demonstrates how to make a waste mold and produce a cast in a durable material. This relief will be a one-off piece cast in very hard, high-quality plaster.

The finished relief panel was sprayed with metallic gold paint. When dry, a toothbrush was used to apply black grate polish diluted with mineral spirits. This was wiped back with a cloth to reveal gold highlights and dark aging in the grooves and recesses.

YOU WILL NEED
MATERIALS
Clay, economical variety for modeling
Plaster, economical variety to make the mold
Water
Yellow ochre pigment or powder paint
Soft soap
Extra-hard sculpting plaster

TOOLS
Wooden board and rolling pin
Cutting sticks and wire
Knife
Modeling tools
Soft brush
Plastic-coated board
Plastic bowl
Dust mask
Scoop
Spoon or stick
Stripping knife
Washing-up brush or old toothbrush
Towel
Mallet
1 in. (2.5cm) wood chisel
Pointed metal tool

1 Enlarge a photograph to the desired size. Cut a slab of clay (see page 18) about 1 in. (2.5cm) thick, slightly larger than the size of your image—here 8½ x 9 in. (22 x 23cm). Lay the photocopy on the clay slab and prick through the image with a sharp point to transfer it. Allow the clay slab to stiffen overnight so that you do not squash it out of shape when adding clay to build up the relief.

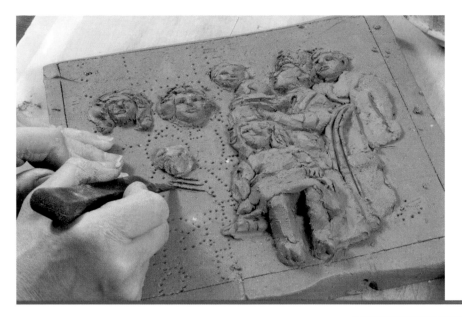

2 Start adding pieces of soft clay for the faces and bodies. Carefully scratch where you want to add clay, wet the scratched area, and press on the soft clay (see page 22).

3 Use small modeling tools to shape the heads, clothes, legs, and shoes.

Remember to work underneath the figures, too.

4 Include some background details in low relief, such as the window here. Features in the foreground, such as the small children's legs, should be raised higher off the clay slab and modeled almost completely in the round. This is time-consuming but it is worth the time and patience. Leave the panel to stiffen overnight before fixing it to a plastic-coated board.

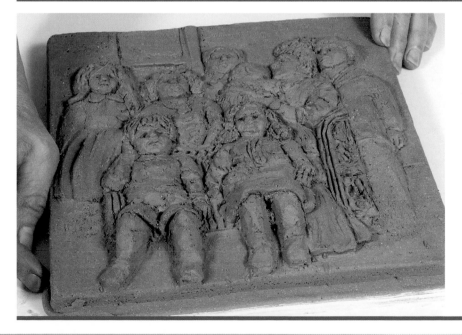

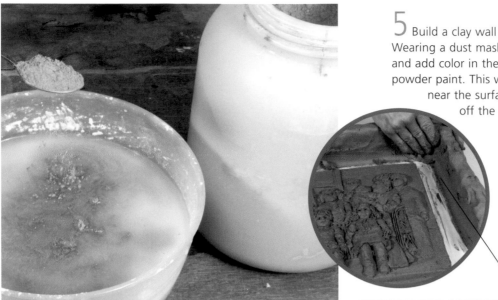

5 Build a clay wall around the panel (see page 55). Wearing a dust mask, mix some plaster (see page 54) and add color in the form of yellow ochre pigment or powder paint. This will show you when you are getting near the surface of the actual cast as you chisel off the mold in Step 12.

Build a clay wall about an inch away from the panel.

6 Pour the tinted plaster over the clay model, making sure that every nook and cranny is filled. Blow on the liquid plaster to fill any holes. Allow this layer of plaster to set, then mix some untinted plaster and fill up to the clay wall to make the mold. You do not need to add any scrim because this waste mold will eventually be chiseled off the cast.

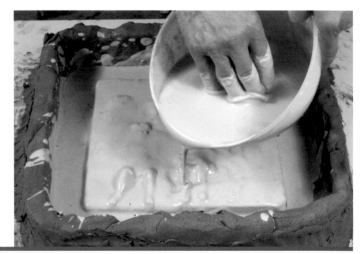

7 Allow at least one hour for the mold to set, by which time it will have heated up and cooled down again. Remove the clay wall and lift the mold off the board with a stripping knife. Pick out the original clay relief tile using wooden tools, taking great care not to break any details in the plaster mold.

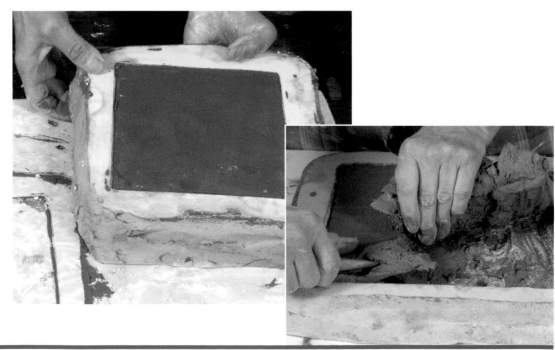

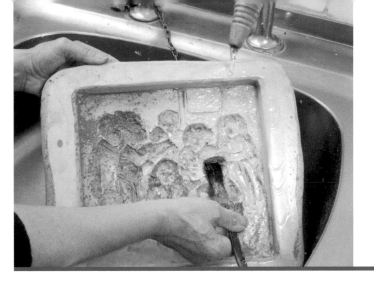

8 Wash all traces of clay out of the mold with water, scrubbing gently with brushes.

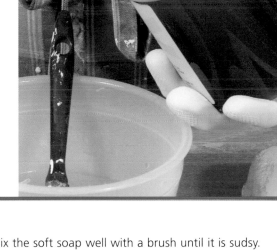

REMINDER
The mold should be kept wet for this casting process.

9 While the mold is still wet, dissolve some soft soap in water. The soft soap acts to prevent the plaster cast bonding to the mold. A generous teaspoonful of soft soap in a small amount of water will be ample.

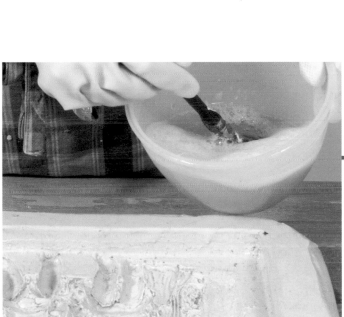

10 Mix the soft soap well with a brush until it is sudsy. Paint the mold thoroughly all over with the soft soap mix and allow any bubbles to disappear. Apply a second coat and again let the bubbles disappear. The mold should feel greasy to the touch.

11 Place the clean, soft-soaped mold on a board. The cast will be made from a very hard, strong plaster that will not crack as you chisel off the waste mold. The plaster should be mixed according to the manufacturer's instructions. Pour the plaster into the mold to fill it. Jiggle the board to make sure that all air bubbles have risen to the top of the liquid plaster. Leave the plaster for at least one hour to set hard.

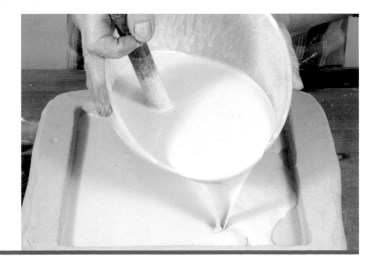

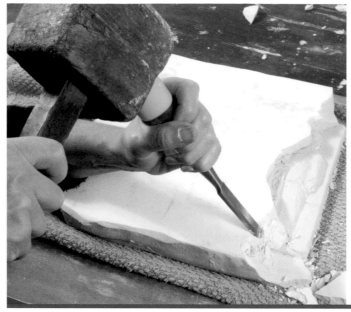

DON'T WORRY
The new hard plaster will expand as it heats up and may cause the mold to crack, which does not matter too much because the waste mold will be chipped away anyway.

12 Turn the mold over onto a folded towel to prevent it slipping. Using a mallet and a 1 in. (2.5cm) wood chisel, carefully start chipping off the plaster mold. The layer of colored plaster will alert you to when you are close to the surface of the cast.

13 Once the major part of the mold has been removed, pick out any mold plaster remaining in the crevices with a pointed metal tool. Brush away small flakes and crumbs of plaster.

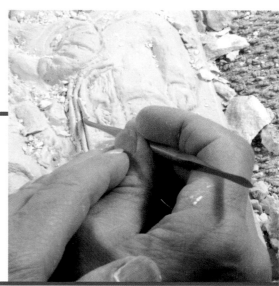

Brush away small chips and crumbs of plaster.

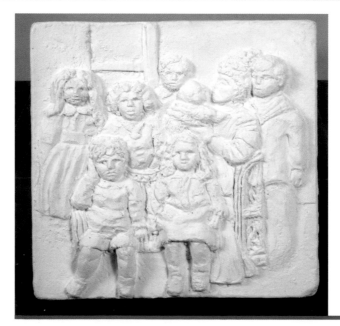

14 When the cast is completely clean, it can be left to dry out before finishing.

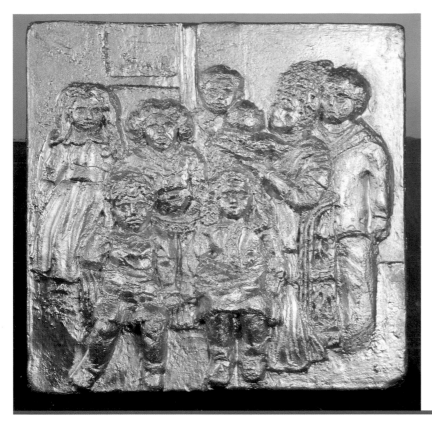

15 Spray the cast with gold metallic spray paint.

SEE ALSO
Clay Modeling
Preparing Clay,
 page 16
Making Slabs, page 18
Joining Soft Clay,
 page 22

Molding and Casting
Mixing Plaster,
 page 54
Making a Mold with
 a Clay Wall, page 55

16 Allow the gold paint to dry and then age the bright gold with black grate polish diluted with white spirit.

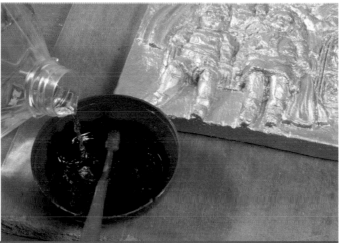

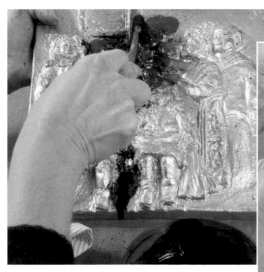

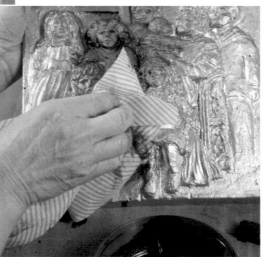

17 Apply the diluted black polish to a small area with an old toothbrush and immediately wipe with a cloth before it dries. This cleans the polish off the raised parts of the relief, leaving the recesses dark. The relief is emphasized and the overall effect is aged.

CLASSICAL FEMALE TORSO:
MAKING A TWO-PIECE REUSABLE MOLD

This project shows you how to make a two-piece plaster mold that can be used to make repeated reproductions of the original sculpture. It builds on the solid modeling skills learned in the Clay Modeling section of the book.

This stylized version of a classical female form is modeled around a simple post armature. The sculpture is based on some of my own life drawings of a female nude, as well as images of sculptures by artists such as Rodin and the Russian Sergei Konionkov.

This female figure is finished with a gray-green glaze to create a heavily marbled antique finish. Using a reusable mold means that the same form can acquire a different character according to the glaze finish.

YOU WILL NEED

MATERIALS
Clay, economical variety for modeling and semi-porcelain for casting
Scrim, coarse and fine
Plaster
Water
Glaze

TOOLS
Post armature (see page 24)
Wooden board and rolling pin
Cutting sticks and wire
Modeling tools
Plastic bowl
Dust mask
Scoop
Spoon or stick
Rasp
Blunt knife
Soft brush
Stripping knife or chisel
String
Fork
Glaze brush

To imprint a gauzy skirt pattern, press a small damp sponge onto coarse scrim.

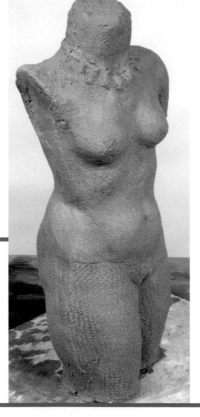

1 Start by making sketches of different views of the sculpture, then construct a post armature (see page 24). Build clay onto the armature and shape your model, in a similar way to the method used in Project 4 (see pages 40–45). Gradually refine the form and finally add surface detail—here damp coarse scrim is rubbed over the clay to indicate the gauzy skirt. The skin surface can be finished off with fine scrim as described in Steps 15–16 of Project 4 (see page 45).

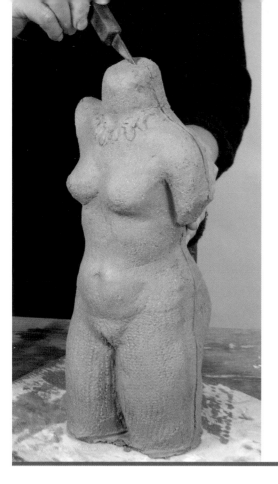

2 Allow the model to harden for about 24 hours, to almost leather-hard. This allows it to lose water and shrink a little so that it has the capacity to absorb water and swell again to aid separation of the two mold halves. Mark out the highest or widest point of shoulders and hips by drawing a line on the model. This is to ensure that there are no undercuts or areas where the model can be trapped in the mold. For reproduction the sculpture has to come out of the mold with ease and without distorting or damaging the form.

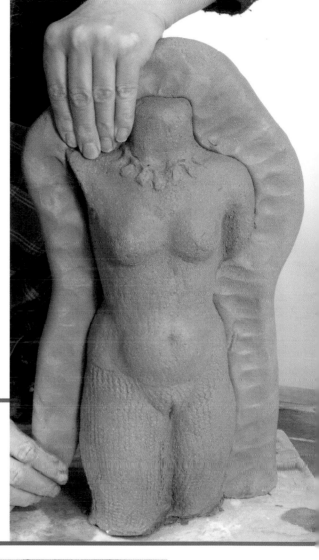

3 Roll out a thick coil of clay (see page 18) and pat it to flatten it slightly for use as a wall. Attach the clay wall around the marked line on the sculpture.

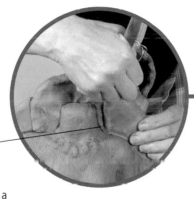

Seal the clay wall with a thin coil.

4 Smooth and seal the side where you will cast the first half of the plaster mold.

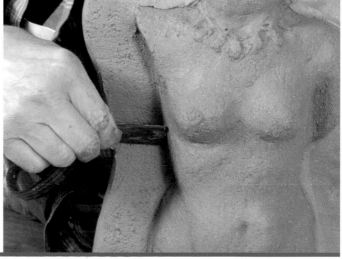

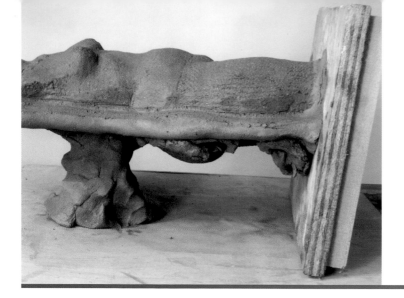

5 Support the clay wall at the back with more clay and then lay the sculpture down in a horizontal position, placing it on lumps of clay.

6 Wearing a dust mask, mix up some plaster (see page 54), stir well, and wait a minute or two until it becomes slightly creamy but not too thick. You want it to flow into all the details and crevices of the sculpture. Gently start pouring plaster onto the sculpture using your hand, padding it gently with your palm to make sure it covers all details.

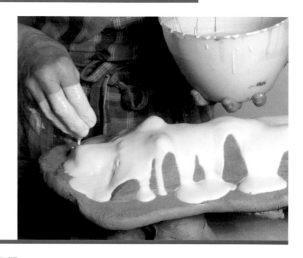

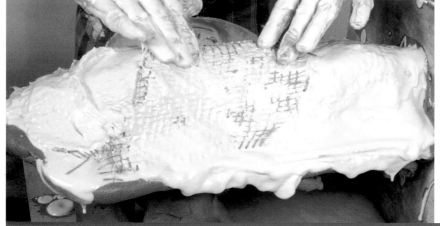

7 When the sculpture is well covered, dip some pieces of scrim into the plaster and lay them over the mold. This will strengthen it. Continue building up as the plaster thickens until the mold is about 1 in. (2.5cm) thick. Work quickly at this stage, because once the plaster becomes too thick, it cannot be used.

8 Once the mold has set hard—this takes at least an hour—it is safe to turn the sculpture over and remove the clay wall ready for casting the second part of the mold. Keep it supported on lumps of clay as before and shave off the sharp edges of the plaster with a rasp.

Carefully peel away the clay wall.

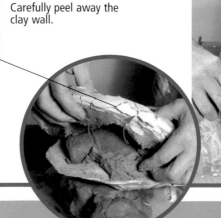

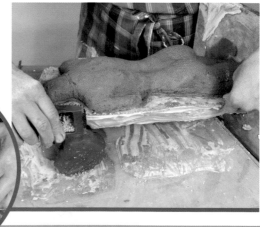

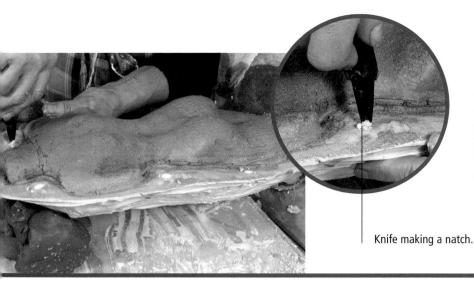

9 Use a blunt knife or similar tool to make a few round dents in the plaster wall. These will fill to form corresponding bumps when the second part of the mold is cast and will help locate the two parts together again after they have been separated. These locating spots are called natches.

Knife making a natch.

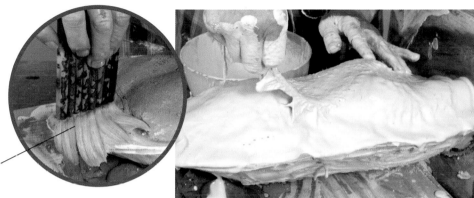

10 Make a clay wash by brushing a small pinch pot (see page 20) with water and brush the slip over the plaster to ensure that the mold halves will come apart easily. Cast the second half of the mold as for the first part and leave to set hard.

Brush the plaster with a clay wash before casting the second half.

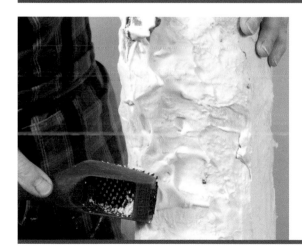

11 Stand the sculpture upright. Some plaster will have dripped over the first half of the mold, covering the seam. File this away with the rasp.

SEE ALSO
Clay Modeling
Preparing Clay, page 16
Making Coils, page 18
Making Pinch Pots,
 page 20
Joining Soft Clay, page 22
Joining Leather-Hard Clay,
 page 22
Making a Post Armature,
 page 24

Molding and Casting
Mixing Plaster, page 54

Finishing Techniques
Firing Clay, page 122
Glazing, page 124

12 You may be able to see a hairline between the two parts of the mold, but often the parts are so close together that the seam is invisible. To separate the mold halves, put the whole sculpture in a sink full of water (or the bathtub if the sculpture is large) and leave it to soak for about two hours. The clay model inside will absorb water and start to swell, pushing the mold apart. The seam will gradually appear, as a hairline at first, and then slowly widen.

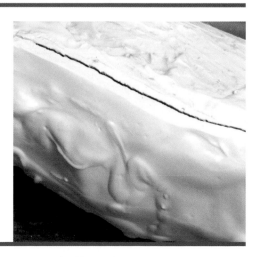

Use a knife to separate the mold parts.

13 When the seam has opened wide enough, insert a stripping knife or chisel and very gently start easing the mold apart. The mold parts can then be separated by hand.

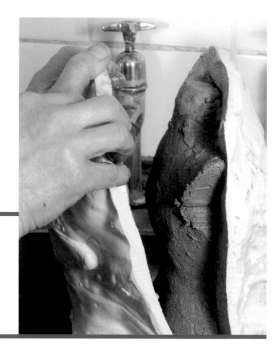

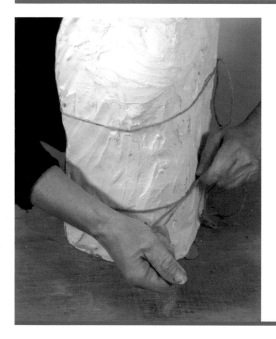

14 Once the model is out, check the mold for holes left by air bubbles and fill them in with thick plaster. Clean all clay off the mold by washing it in water, scrubbing gently with a brush. Put the two parts of the mold together, locating them with the natches, and tie them tightly with string. This prevents the mold from distorting as it dries. The mold has to be completely dry before it can be used for pressing clay reproductions, so leave it in a warm place for about one week.

TIP

If you have had trouble with areas that did not release easily due to being undercut, carve away those parts of the mold. It is best to avoid having to do a lot of this by careful shaping of the original model and locating of the clay wall.

15 To make casts, choose the clay you would like to use; a semi-porcelain mix is used here. Cut some soft slices of clay about ⅜ in. (1cm) thick and press them firmly into one half of the mold, smoothing them together well. Make sure that the clay does not get too thin over ridges in the mold, such as the line between the legs. Add more clay here if necessary. Level the clay at the edges of the mold using a wooden or plastic tool to avoid cutting the plaster. Repeat this process with the second part of the mold, then rough the seam edges with a fork and wet them ready for joining.

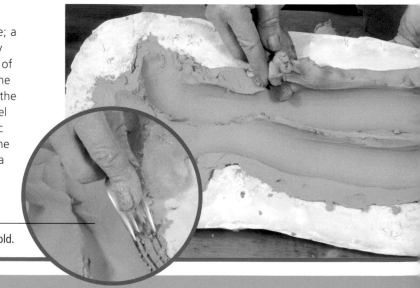

Scratch the clay at the edges of the mold.

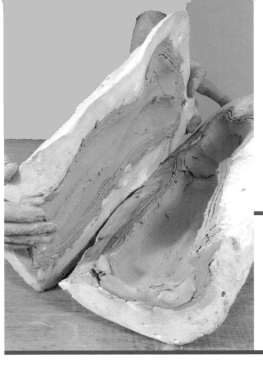

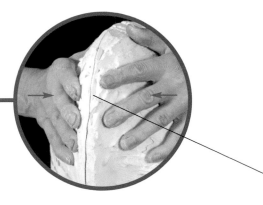

16 Put the two parts of the mold together and press well. Tie them up with string and leave for at least four hours, or overnight, for the new sculpture to become leather hard.

Press the two parts of the mold together firmly around the seam.

17 Remove the replica from the mold. The sculpture should be able to stand up.

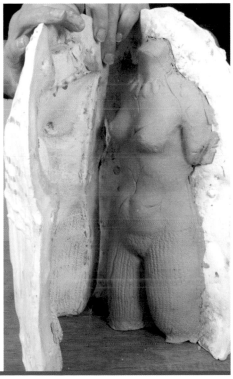

18 The seam needs to be reinforced, so use the joining technique of scratching, wetting, and adding a small coil of clay (see page 21). Smooth the seam and tidy up any surface flaws where the clay slices abutted in the mold, using modeling tools and tiny additions of clay where necessary.

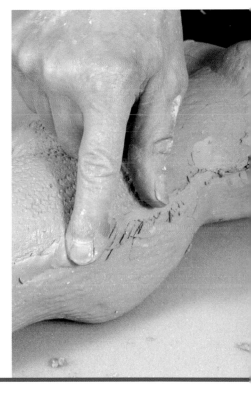

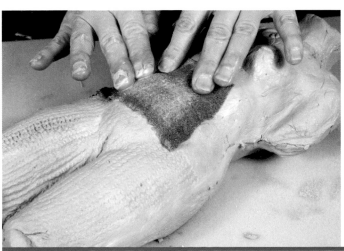

19 Touch up the gauzy skirt with damp, coarse scrim and finish off the skin surface by rubbing your fingers over pieces of damp fine scrim. Leave to dry completely before glazing and firing.

TOAD: CASTING IN CEMENT FONDUE USING A WASTE MOLD

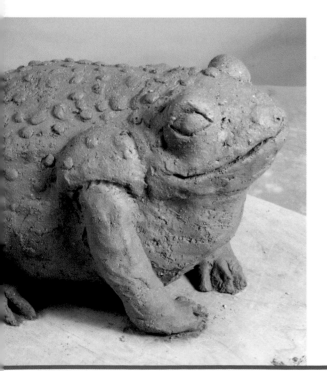

This project builds on the mold-making techniques in Project 8 and the solid modeling processes shown in Projects 1, 4, and 8. You will learn how to make a three-piece waste mold and cast the final sculpture in cement fondue.

Cement fondue is very strong, so large sculptures can be cast as a hollow, lightweight shell. If carefully cast, these sculptures will withstand most weather conditions.

A toad has a compact body form so it can be modeled without the need for an armature. The form of the toad is complex around the legs and feet and it will be impossible to avoid undercuts here, so the mold will have to be a waste mold. The mold needs to be carefully planned so that all parts are accessible for removing the clay original and filling with cement fondue. Your toad could end up without toes or feet if some way of reaching into these recesses is not considered when making the mold.

Cement fondue toad, approximately 15 in. (37cm) in length. The toad has been polished with grate polish to give a dark metallic finish.

YOU WILL NEED

MATERIALS
Clay: heavily grogged coarse clay such as Potclays Tandoori saggar clay for modeling and economical variety for the clay walls
Plaster
Water
Soft soap
Cement fondue, about 9 lb (3 kg)
Fine silica sand, about 3 lb (1 kg)
Sharp sand, up to 30 lb (10 kg)

TOOLS
Wooden board
Modeling tools
Upholstery foam pad
Plastic bowl
Dust mask
Scoop
Wood block
Soft brush
Kitchen paper towel
Blunt knife
Plastic cup
Old spoon
Strong rubber gloves
Household paintbrush
Fiberglass mat
Cloths
Spray mister
Mallet
Straps for securing the mold
Chisel
Towel
Polythene
Pointed metal tool or Carborundum stone
Wire brush

1 Model the toad on a board using coarse saggar clay, referring to pictures and drawings of an actual toad. The toad should be modeled completely solid. Shape the legs from thick coils of clay and join them to the body (see pages 18 and 22). Create the warty skin by adding small beads of clay to the back and legs, pressing them firmly to the surface. Hold a piece of upholstery foam on top of the toad and put one hand under the board, and turn the sculpture upside down. Make sure that the lowest part of the belly and the soles of the feet are all level, so that the toad will not wobble. When the underside has been finished, turn the toad right side up again and allow it to dry to the leather-hard stage before making the plaster mold.

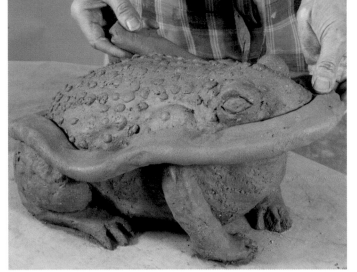

2 The seams of the mold should be located in positions where they will be the least unsightly, avoiding areas of intricate detail, such as the eyes. The head and back of the toad are a simple curved form, so make this the first and biggest section of the mold by building a clay wall around the widest part of the sides using an economical clay. Mix up a small quantity of plaster (see page 54). Cast the first section of the mold as shown for the female torso in Project 8 (see Steps 6–7, page 70). Make natches along the edge of the plaster mold as shown in Project 8 (see Step 10, page 71) and give it a clay wash.

TIP
Just as the plaster is setting, use a block of wood to smooth the top of the mold flat. This is so the mold will be stable when turned over for casting the underside of the toad.

SAFETY
Remember to always wear a dust mask when working with plaster powder. If you have sensitive skin, it is probably a good idea to apply a barrier cream to your hands before handling liquid plaster.

3 Build a second clay wall around the back legs and cast the second part of the mold. When that section has set, remove the clay wall, make natches on the edge of the section, apply a clay wash, and cast the third and final piece of the mold. At each stage make sure the plaster has completely covered every detail of the toad. Flick liquid plaster well into any overhangs and take particular care that air bubbles do not get trapped in intricate areas. When the whole mold has been cast, immerse it in water for a couple of hours until the seams start to open.

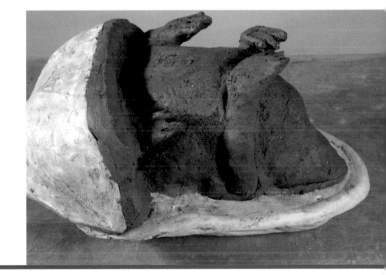

4 Remove all the clay from the mold and wash it out extremely well. Force jets of water into the toe sockets and use brushes and a fine modeling tool to pick out any persistent remaining clay. Any clay left in the toe cavities will mean that the toes will be lost in the final cement fondue cast. Thoroughly clean the mold and use it while still wet. A dry plaster mold would suck water from the wet cement fondue mix, preventing it from setting properly. It should be used as soon as possible.

If the mold cannot be used right away it should be strapped together to prevent warping and stored wrapped in soaking cloths and polythene.

5 When you are ready to cast the sculpture, brush the mold very thoroughly with soft soap as described in Project 7 (see Steps 9–10, page 65). Blot away any excess soft soap liquid with paper towels. Keep the mold wet.

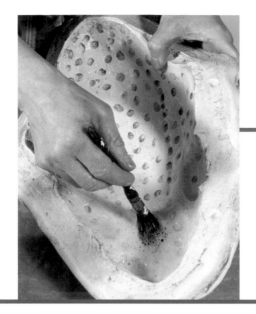

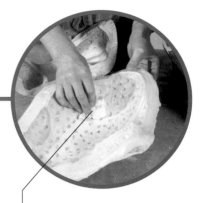

Use paper towels to clear away excess soap liquid.

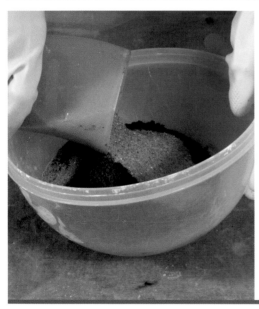

6 Like building mortar, cement fondue needs to be mixed with sand. The main structure of the sculpture is made with a mix of the cement fondue powder and sharp sand. This is quite a stiff mix and will not pick up fine detail or create a smooth surface, so the cement fondue is applied in stages. The first step is to mix up a creamy slurry of cement fondue powder and water. Without sand, it is suitable for small sculptures or for any that are to be kept indoors. For outdoor use, mix 2 parts fine silica sand with 1 part cement fondue powder, adding enough water to allow you to apply the mix with a brush. A plastic cup makes a good measuring tool for volumes of cement, sand, or water. Use an old spoon to stir the mixture.

SAFETY
Always wear rubber gloves when working with any form of cement. It is very alkaline and can cause burns on the skin.

7 Work on one section of the mold at a time, creating just enough mixture to work on that section. Wearing rubber gloves, apply the slurry to the mold with a brush, working it into all the details and coating the surface evenly to about ⅟₃₂ in. (1.5 mm) thick.

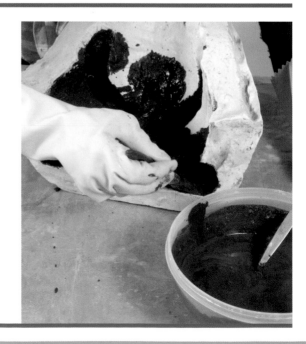

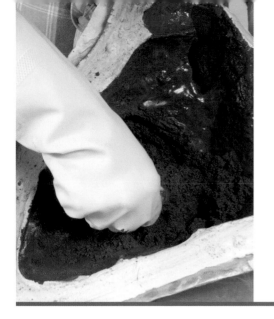

8 Next, make up the standard cement fondue mix using the ratio of 2 parts cement fondue powder, 6 parts dry sharp sand, and 1 part water. This will be very stiff but as you apply it to the slurry coat it will absorb some of the water in the slurry layer. Press the cement mix into the mold, gradually pushing a wave of slurry in front. It is the job of the slurry to be displaced, enabling the cement mix to fill all details. Pat the standard cement mix firmly into the mold to a thickness of about ¼ in. (6 mm). The mix should be firm so that it cannot be impressed with a finger.

9 To reinforce the cast, create some more cement fondue slurry without any sand. Paint some slurry onto the layer of pressed cement. Tear off a piece of fiberglass mat, dip it into the bowl of slurry, and work the slurry well into the fibers by rubbing it between your fingers.

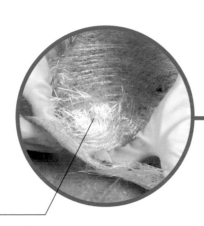

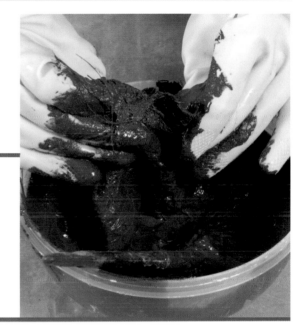

Fiberglass mat is easy to tear or cut and offers good reinforcement.

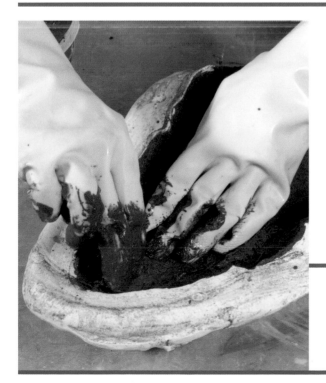

10 Lay the fiberglass in the mold. Continue applying small pieces of mat until you have covered the mold surface. Brush on some more slurry, making sure that all the fiberglass is lying flat and even, and then press in a final layer of stiff cement fondue mix so that the resulting thickness is about ½ in. (13 mm). Tamp the fondue firmly.

Use the brush and slurry to lay the fiberglass mat flat, then pat the mat down with the brush.

11 Clean off the edges of the mold, making sure that none of the cement mixture is raised above the seam edges of the mold. Leave the mold section on one side under a soaking cloth to cure for 24 hours. Cement fondue sets hard by a process of curing, not drying, so it must be kept wet until it is completely hard. Drying out prevents proper setting, leaving the cement weak and crumbly. Repeat the process of lining the other mold sections in the same way and leave to cure under wet wraps for 24 hours. Each mold section will be lined with a sandwich construction of cement fondue and fiberglass built up as follows:

- slurry mix and cement fondue standard mix
- fiberglass and slurry mix
- cement fondue standard mix.

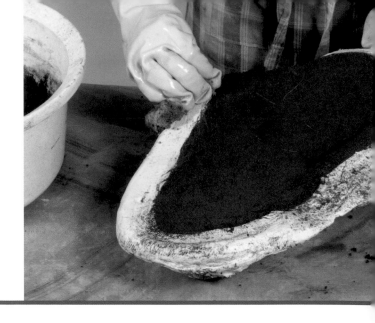

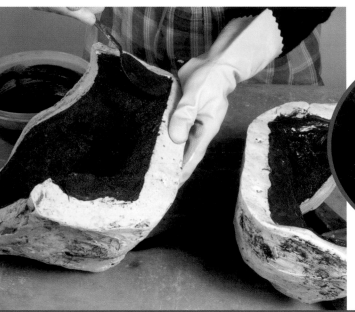

12 When all sections of the mold have cured, the seams can be joined with cement fondue slurry. The mold should be wet, but as an additional precaution spray each section with water to make sure that everything is well moistened. Make up more slurry without sand and apply it to the seams of the sections to be joined. Start with the two pieces for the underside of the toad.

Keep the mold and cast wet.

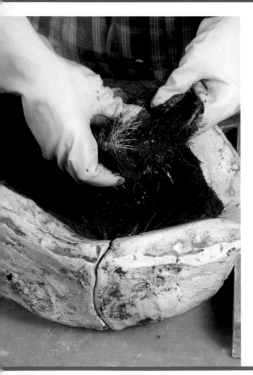

13 Press the two molds together and support them in position with a block of wood. Apply more slurry to the inside of the seam and reinforce it with pieces of fiberglass dipped in slurry.

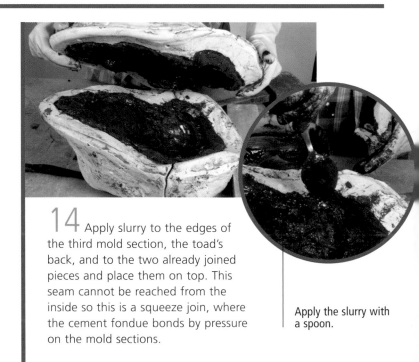

14 Apply slurry to the edges of the third mold section, the toad's back, and to the two already joined pieces and place them on top. This seam cannot be reached from the inside so this is a squeeze join, where the cement fondue bonds by pressure on the mold sections.

Apply the slurry with a spoon.

15 Tap the mold pieces together with a mallet, then strap the pieces firmly to keep them in position. Give a final tap with the mallet, wrap the entire mold in a soaking wet towel, and store inside polythene to cure for 24 hours.

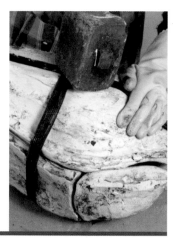

16 When the seams have cured, place the mold on its back on a folded towel to prevent it from slipping and carefully chip off the plaster, using a mallet and chisel. Take great care not to chip into the sculpture. As soon as you see the gray cement fondue appear, work very gently.

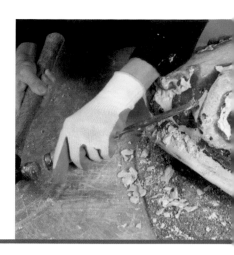

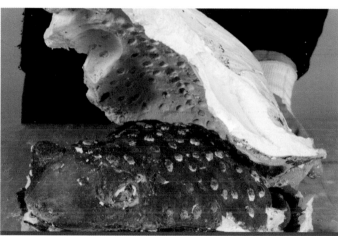

17 When most of the toad's underside has been revealed, turn it over and remove the back mold. If there are no undercuts, it will lift away easily.

SEE ALSO
Clay Modeling
Preparing Clay, page 16
Making Coils, page 18
Joining Soft Clay, page 22

Molding and Casting
Mixing Plaster, page 54
Project 7, page 62
Project 8, page 68

Finishing Techniques
Surface Finishes, page 120

18 The small pieces of plaster in crevices can be removed with a small metal pointed tool, and raised seam edges can be filed down with a Carborundum stone. Plaster leaves a white bloom on the surface of the cement fondue—this can be scrubbed away with a wire brush.

19 Cement fondue has an attractive gray finish after the bloom has been scrubbed off. Any small defects in the surface can be repaired or touched up with cement fondue slurry. Leave to cure under wet cloths for 24 hours. The repairs and seams may be a different color from the rest of the sculpture. Cement fondue can be painted or polished.

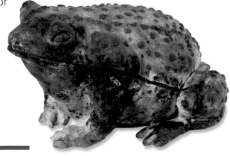

DIRECT BUILDING

TRADITIONALLY, METHODS OF making sculpture were limited to carving and modeling. However, in the twentieth century, new techniques, most notably welding metal, enabled the direct construction of sculpture. The invention of plastics and the use of found materials has opened up a great range of possibilities in building sculptures.

This section builds on skills learned in the previous sets of projects. You will make an armature to support the construction of sculptures with plaster and added materials such as fabric, buttons, and a range of other items.

TOOLS

The tools you require include wire cutters, a hacksaw, and pliers for making the armatures and a small plaster trowel, as well as a selection of rasps and files.

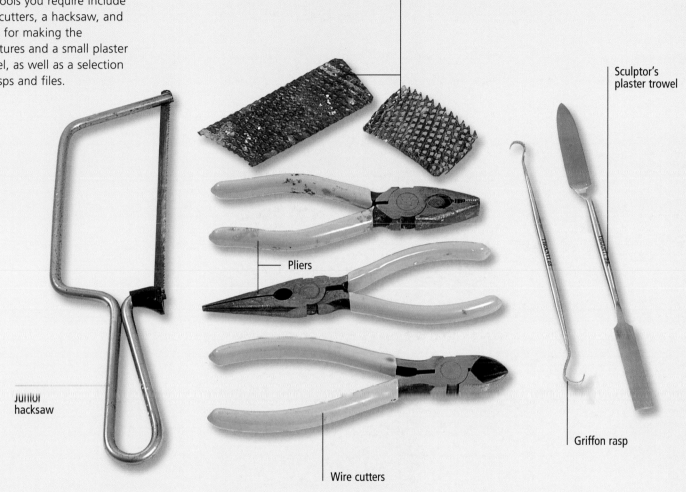

Surform rasps

Sculptor's plaster trowel

Pliers

Junior hacksaw

Griffon rasp

Wire cutters

CONSTRUCTED SCULPTURE

For complex poses, such as a figure with outstretched limbs, a simple post armature does not provide enough support. So, for small-scale complex sculptures, armature wire can be bent into shape to make a good framework on which to build. These armatures can be used for modeling with clay or for direct building with plaster.

MAKING A WIRE ARMATURE FOR A FIGURE

YOU WILL NEED

MATERIALS
Wood block
Bamboo cane
Fast-setting strong
 adhesive or wood glue
Armature wire, ³⁄₁₆ in.
 (5mm)
Wire twists
Wire staple

TOOLS
Drill
Wire cutters
Hammer

The armature wire needs to be fixed to a base, such as a block of wood, and, because the wire is flexible and can bend, extra strength and rigidity is required for the legs of a figure that supports weight.

It is important to study and understand the position of the figure from all viewpoints, so try to work from as many photographs and drawings as possible, and have your sculpture well planned out in advance of starting out—once you have made the armature it is very difficult to alter the basic form of the figure.

The following armature is taken from the dancing figure featured in Project 10 (see pages 84–89). In the case of the dancing pose all the weight is supported on just one leg so extra support is made from a piece of bamboo cane—or doweling—to fit the length of the leg. You may also wish to practice making a wire armature on a standing figure with both feet attached to the base.

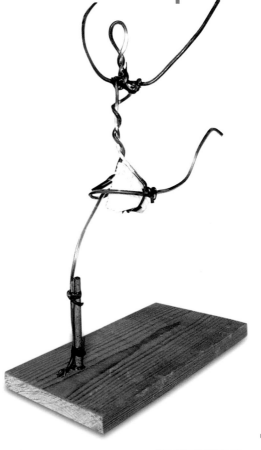

Distribute the glue with a cotton swab.

1 Start the armature by drilling a hole in a wood block to fit the bamboo cane for the leg support. Insert the cane into the hole and set with fast-setting strong adhesive or wood glue.

2 Use wire cutters to cut a suitable length of armature wire and bend it into a "U" shape so that the legs will be of equal length.

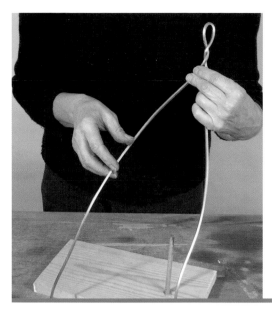

3 Make the head by twisting the armature wire around itself to form a small loop.

4 Cut a second piece of armature wire to form the arms. Hold this against the body armature at shoulder level and twist each long piece of the body wire around it to make the shoulders.

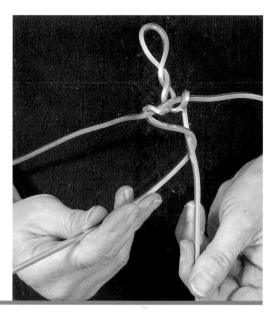

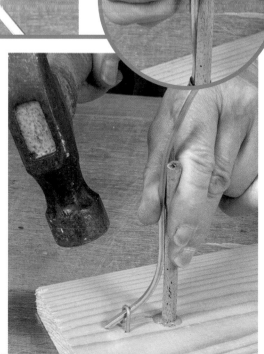

5 Fix in position with wire twists.

Secure the leg to the cane with wire.

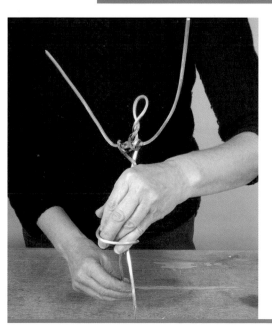

6 Form the hips and the raised leg by twisting the armature wire around your fingers.

7 Attach the toe end of the supporting leg armature to the wood block with a wire staple and secure it to the cane support with wire twists.

DANCING FIGURE:
DIRECT BUILDING ON A WIRE ARMATURE

This project is intended to focus on posture and movement in the figure. Rather than detailed modeling of every feature, the aim will be to convey the overall shape and gesture of the form.

Fluid plaster cannot support itself, so it has to be applied to an armature and built up in stages to model the form. Plaster cannot be removed from the armature once it has set, so the armature becomes an integral part of the sculpture. After setting, the plaster can be filed, carved, and smoothed to refine the shape and surface of the sculpture. This project also shows how texture can be built into the sculpture using pieces of fabric.

The pose of the dancing figure is supported on only one leg, while the other leg is stretched out behind. This means that the armature needs to be extra strong and rigid on the supporting leg, and care must be taken not to build up too much weight on the unsupported part of the sculpture.

The completed figure was sprayed with silver metallic paint.

YOU WILL NEED
MATERIALS
Wire figure armature (see page 82)
Styrofoam (packing pieces)
Wire twists
Plaster bandage
Water
Plaster
Scrim (coarse and fine)
Lacy fabric

TOOLS
Scissors
Plastic bowls
Dust mask
Scoop
Spoon or stick
Small plasterer's trowel
Modeling tools
Surform rasp
Scourer

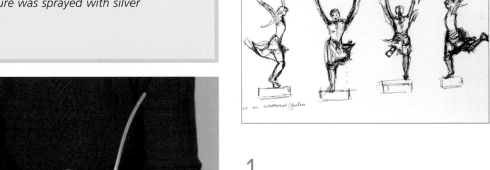

1 Start by sketching the posture of the dancer. Make a wire armature (see page 82), following the posture created in the sketches. The weight of the sculpture will extend out behind the supporting leg, so pad out the armature with light material such as styrofoam and fix with wire twists. This will avoid adding too much heavy plaster to the unsupported part of the armature at an early stage.

Pad the armature with pieces of styrofoam.

2 The next step is to reinforce the armature and begin defining the shape, using plaster bandage and water. Have a bowl of clean water ready and cut small pieces of plaster bandage as you need them.

3 Dip a piece of plaster bandage in the water and wrap it around the supporting leg of the figure.

4 Carefully continue dipping and applying the bandage to the rest of the armature. Allow the bandage to set hard before applying more plaster.

Use plaster bandage to secure the padding.

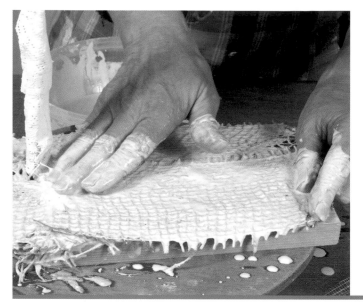

5 Wearing a dust mask, mix up a small quantity of plaster (see page 54) and allow it to thicken a little. Dip in some pieces of coarse scrim and drape them over the wooden base to start the plinth.

(see page 54)

SAFETY
Sensitive skin may well become irritated when handling liquid plaster directly, so it can be a good idea to use a barrier cream on your hands when working this way.

6 Continue mixing small batches of plaster to build up the figure. Dip pieces of fine scrim into the plaster to pad out the body and wind some plaster-soaked scrim around the arms. Bulk out the body and lower leg with plaster and scrim.

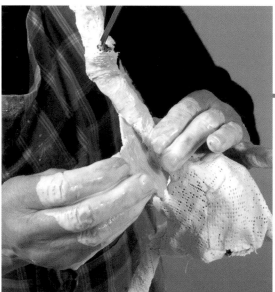

Keep the plaster bandage stretched to make an even wrap.

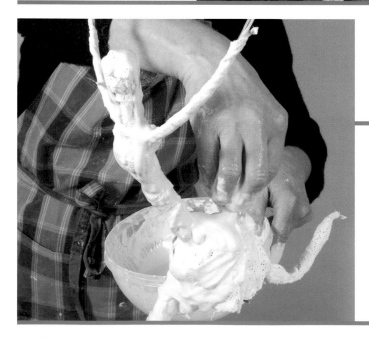

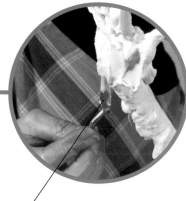

Use a plasterer's trowel to apply and smooth the plaster.

7 As the plaster thickens, apply it to the body with your fingers, then apply the thickest plaster to the sculpture using a small plasterer's trowel. Work quickly at this stage, smoothing and controlling the surface as much as possible. Once the plaster turns stiff and heavy, it cannot be used, so throw it away and mix a fresh batch.

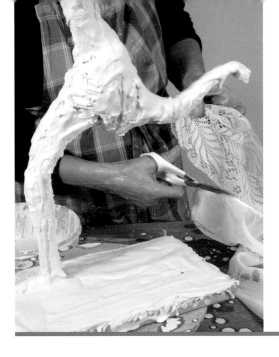

8 Next add the lacy fabric. First experiment with pieces of fabric and decide where you want to place them.

9 Mix up some fresh plaster and, while it is still runny, dip in a piece of the lace holding it outstretched. Make sure that it is well soaked in plaster and drape it around the figure.

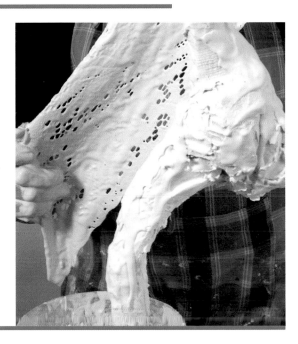

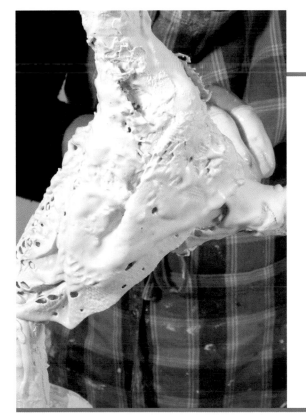

10 Arrange the folds and smooth the fabric securely onto the sculpture at the waist. Add a second piece of fabric in the same way to finish the shape.

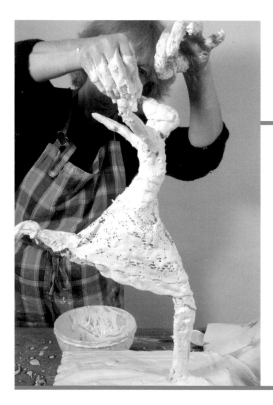

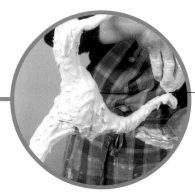

Drip plaster on to the sculpture to make the foot.

11 Use thickening plaster with a modeling tool, trowel, or fingers to add the hair, then rake it into shape and texture using modeling tools.

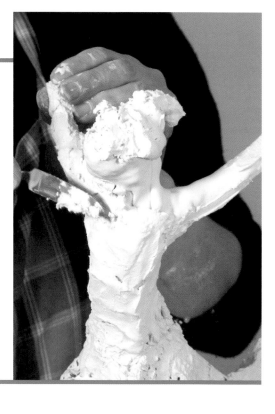

12 Continue building up with plaster using the small trowel. When you are happy with the sculpture, leave the plaster to set.

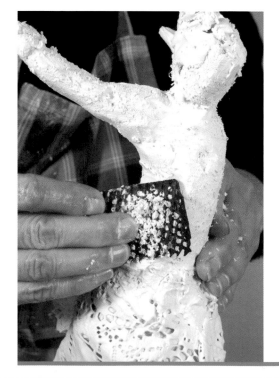

13 When the plaster has set, smooth the surface of the body, face, arms, and legs with a surform rasp, to provide a contrast with the fabric texture.

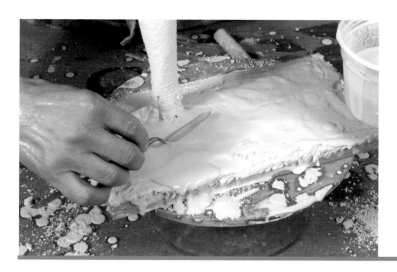

14 Continue to build on your model, refining the shape as much as possible as you go. Remember to build on the base block as well.

SEE ALSO
Molding and Casting
Mixing Plaster, page 54

Direct Building
Making a Wire Armature For a Figure, page 82

15 Finish off the surface with a damp pan scourer and leave in a warm place to dry completely.

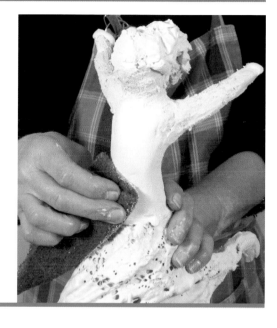

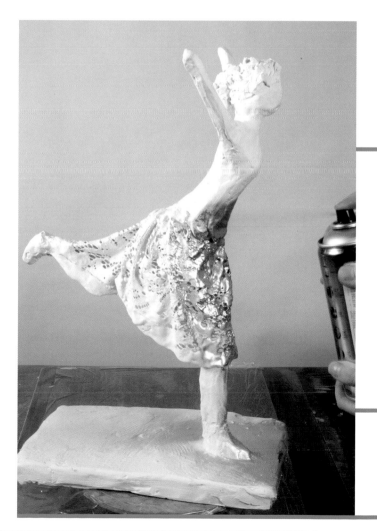

16 Spray the sculpture with silver metallic paint.

When using spray paint, work in a well-ventilated area.

BOLIVIAN DEVIL DANCER:
DIRECT BUILDING ON A CHICKEN WIRE ARMATURE

Every year, the mining town of Oruro in Bolivia holds a carnival featuring the Diablada (Devil) Dancers. The dancers wear elaborate masks that represent dragons and other creatures from subterranean depths. Embellished with horns, dragon teeth, lizard frills, and bulging eyes, the masks may also feature birds, toads, and snakes as part of the ornamentation. The masks are usually made of plaster and other materials such as mirror glass, rubber tubing, and light bulbs for eyes.

Although representative of a Bolivian Devil Dancer, this project is about an imaginative or fantastical sculpture and uses a variety of different materials in combination with a basic chicken wire and plaster frame. It builds on the skills demonstrated in Project 10 (see pages 84–89).

To decorate this Devil Dancer, use furry wire stripes on the lips, large sequins on the nose, self-adhesive braid around the horns, and acrylic paints to add bands and spots of color.

YOU WILL NEED
MATERIALS
Armature wire, ⅜ in. (10 mm)
Chicken wire
Wire twists
Plaster bandage
Water
Plaster
Scrim (coarse and fine)
Lacy fabric
White latex paint
Gold metallic paint
Decorative materials: a variety of assorted materials, such as flashlight bulbs, springs, buttons, mirror glass, fabric, acrylic paints, metallic paints, colored lamellae, and fake hair. Many of these are obtainable from hobby and craft stores.
Strong, clear glue

TOOLS
Paper and pencil
Hacksaw
Pliers
Wood block
Wire staples
Hammer
Gardening gloves
Wire cutters
Plastic bowls
Scissors
Dust mask
Scoop
Spoon or stick
Small plasterer's trowel
Surform rasp
Household paintbrush
Card
Artists' paintbrushes, if using acrylic paint

1 First, make some drawings of your dancer and a diagram of how to construct the armature for the figure.

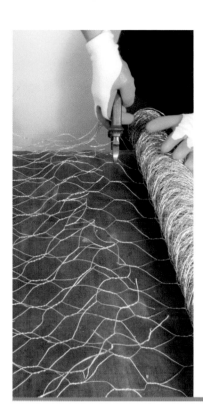

2 Cut a 3 ft (90 cm) length of ⅜ in. (10 mm) armature wire using a hacksaw—this wire is much tougher than the wire used previously. Bend the wire over the edge of the table, twist the top to form a loop to hold the head, and bend the ends with pliers to form the feet. Attach the feet to the wooden base board with wire staples (see page 83). Using wire cutters, cut a wide strip of chicken wire.

SEE ALSO
Molding and Casting
Mixing Plaster, page 54

Direct Building
Making a Wire Armature For a Figure, page 82

Finishing Techniques
Surface Finishes, page 120

SAFETY
Wear gardening gloves when handling chicken wire to protect your hands from the sharp ends created by cutting through the wire.

3 Roll the chicken wire into a short, wide cylinder and connect the seam by bending the cut ends around each other. Drape the cylinder over the armature wire, squeeze it around the head loop, and secure with wire twists. Cut smaller strips of chicken wire, roll them into cylinders, and wrap and scrunch them around the legs of the armature. Secure with extra wire staples if necessary.

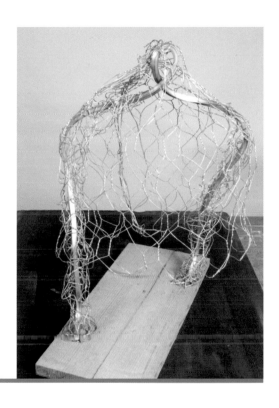

4 Cut more chicken wire and form the head by twisting and squeezing the wire into shape.

Wear gloves when squeezing and pinching the wire frame into shape.

Twist out the side extensions of the head.

5 Fix the head to the body using wire twists.

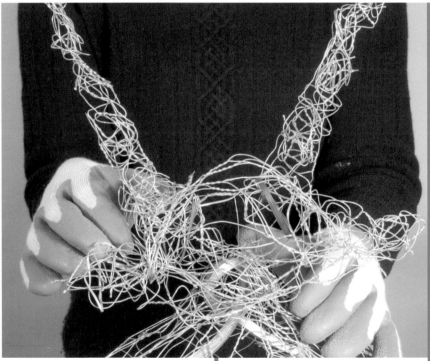

6 Twist the long horns from small pieces of chicken wire into pointed tubes and attach these to the head.

Use wire twists to fix the horns to the head.

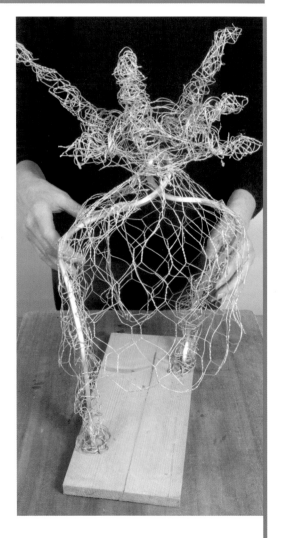

7 The wire framework is now complete.

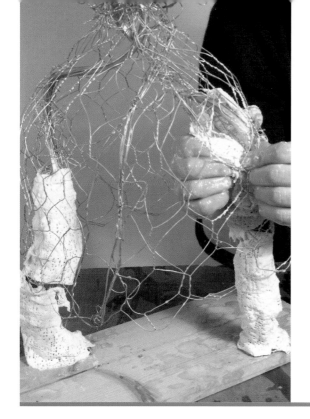

8 Use plaster bandage to strengthen the framework and to make a base for adding more plaster and the miscellaneous materials. Cut a piece of plaster bandage off the roll with scissors. Dip it in clean water and wrap it around a leg. Continue adding pieces of bandage to the feet and legs.

TIP
Plaster bandage is expensive, so you may want to continue reinforcing the framework using scrim dipped in creamy plaster.

9 When the legs are set, cut a large piece of plaster bandage, dip it in clean water, and wrap it around the body of the sculpture. Wrap the whole body in bandage adding a little around the neck. Do not wrap the head or horns yet.

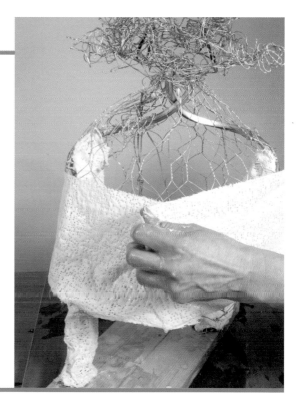

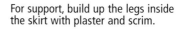

10 Allow the body bandage to set. At this stage, it is like a hollow bell. Most of the weight of the plaster will be added to the head to form the mask, so the inside of the body will need reinforcing. Wearing a dust mask, mix up a small quantity of plaster (see page 54) and allow it to thicken a little. Turn the sculpture on its side, then dip pieces of coarse scrim in the plaster and stuff these well up inside the skirt. Build up the legs with plaster and scrim at the same time.

For support, build up the legs inside the skirt with plaster and scrim.

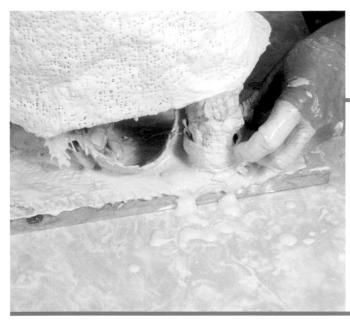

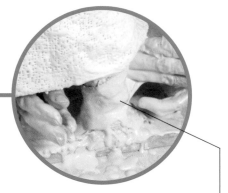

Use plaster and scrim to give the legs solidity.

11 Allow the plaster to set before turning the figure right side up again. Build up the feet with plaster and scrim.

TIPS
- Mix up small batches of plaster as you continue building so you don't waste too much.
- Have a second clean bowl ready for making a new plaster mix while surplus plaster in the first bowl sets. It can then be easily cracked out of the bowl. Keep alternating the bowls until all modeling work has been completed.

12 Dip a piece of lacy fabric into creamy plaster to form the hem of the Devil Dancer's cape.

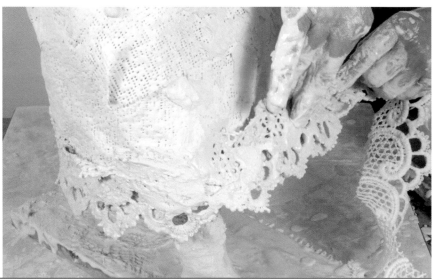

13 Wrap fine scrim dipped in plaster around the head and horns.

Apply scrim dipped in plaster directly to the wire of the ears. There is no need for plaster bandage.

14 Apply thick creamy plaster to the head and figure, using your fingers and a small trowel. Refine and control the surface using a surform rasp and the trowel. Work quickly at this stage, smoothing and controlling the surface as much as possible. Once the plaster turns stiff, it cannot be used, so throw it away and mix a fresh batch.

15 Make eyes from springs and flashlight bulbs and adhere them to the face with small blobs of plaster. When the plaster has dried out, which will take a couple of days, prime the surface with white emulsion paint.

16 When the emulsion paint is dry, spray the whole sculpture with gold metallic paint (see page 121). Now the figure is ready for decorating and embellishing. Assemble the items you plan to attach to the figure.

17 Use a strong, clear glue to place decorative additions onto the sculpture. Coat the spot to be covered with a thin layer of the glue and, if necessary, use a small piece of card to spread the glue. Add a little glue to the item to be fixed and leave for about five minutes; it should become dry and tacky. Press the decorative item firmly into position.

For accuracy and control, apply glue with a tube nozzle.

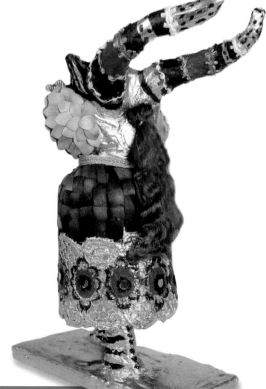

18 Various buttons and braids were added to the costume and false hair was fixed to the back.

CARVING

CARVING IS ONE of the main techniques of sculpture. It differs from modeling because instead of adding material to build up a form, carving is a process of taking away. Removing material from a block of stone or piece of timber has to be carefully planned because once a piece has been cut away, it cannot be replaced.

In this book, the principles of carving are demonstrated on materials that are inexpensive and easy to carve. You do not need to buy specialist stone chisels to cut plaster or cinder block; these materials can be cut with a wood saw and wood chisels. A selection of files, rasps, and small rasps called rifflers will be used for defining fine details.

TOOLS

Once you have practiced carving on these soft materials, you will be able to move on to wood or stone, which are harder to cut and have a grain that needs to be taken into account.

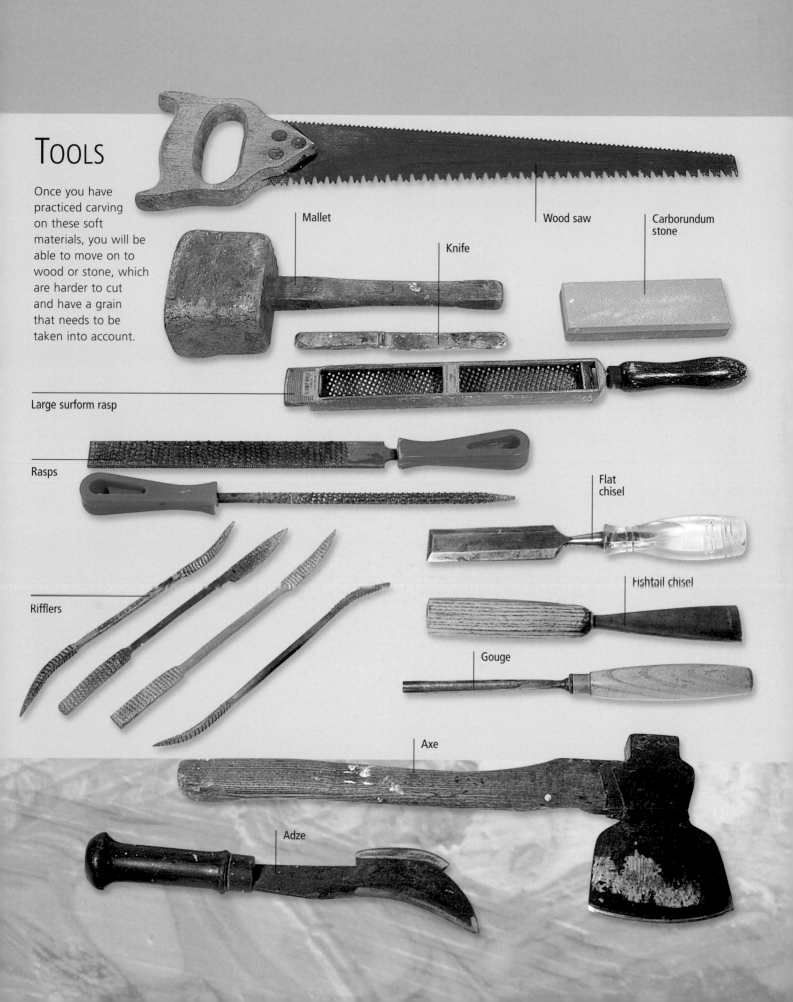

Wood saw

Mallet

Knife

Carborundum stone

Large surform rasp

Rasps

Rifflers

Flat chisel

Fishtail chisel

Gouge

Axe

Adze

CARVING TECHNIQUES

There are several techniques involved in carving, depending on the material you use. Because you cannot put back anything you take off while carving, it is essential to plan out your work in drawings and small clay models called maquettes. We will be working from a maquette in Project 13, carving a Pharaoh head (see pages 106-111). Once you have made a maquette, you can use it to draw out your sculpture on the block you are going to carve.

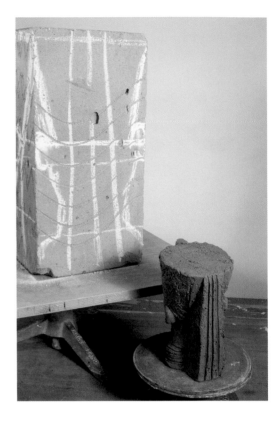

For carving, a maquette is valuable because you can look at it from all angles, which helps visualize the three-dimensional form.

SAWING

Sawing is often used for carving wood, roughing out the form in the early stages, and removing large pieces of unwanted material. Special power saws can be used to cut stone, but here we use fairly soft materials, such as plaster and cinder block, which can be cut with ordinary handsaws. Sawing plaster and cinder block is a relatively straightforward process.

Care needs to be taken when cutting along a grain in wood or stone to avoid splitting the material and removing more than you want. Make a cut across the grain at the point where you want to cut, then saw toward the cross-cut.

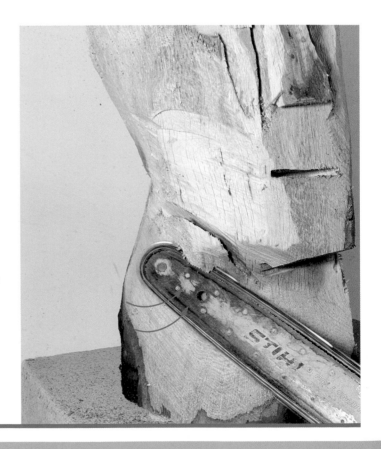

CHOPPING AND CHISELING

These are also basic carving techniques. An axe or adze—a type of axe with a curved blade—can be used to chop away wedges or large chips of material. Again, it is advisable to make a cut across the wood grain before taking a bold stroke with the axe along the grain.

Chisels and gouges are used to cut away smaller pieces of material and to refine the details on the sculpture.

As a general rule, once you have planned what to carve away, start by removing large pieces of material and work down, taking away smaller and smaller amounts. As you work you will use progressively smaller tools to make the fine details and refine the sculpture.

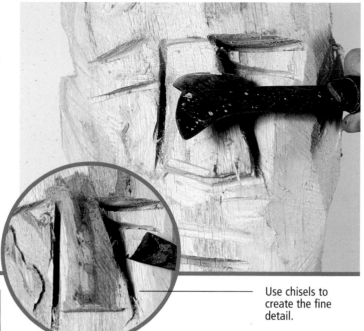

Use chisels to create the fine detail.

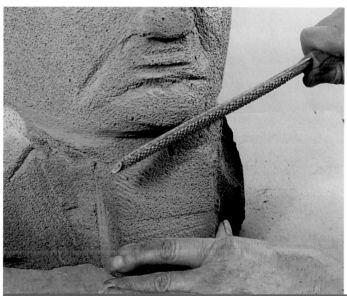

FILING

These techniques are usually used to refine and smooth the surface once the main form of the sculpture has been carved. In the case of some easily carved soft materials, such as cinder block, filing may be the major shaping process once excess material has been cut away with a saw.

SANDING

Sanding is used for final smoothing of the surface. Power sanding tools can be used on wood or stone. Sandpapers, glass papers, or wet and dry papers of different grades from coarse to fine can be used for finishing a variety of materials. Plaster sculptures, for example, can have a very smooth surface by using metal or nylon pan scourers.

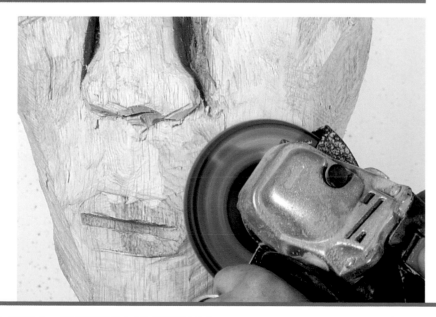

STANDING STONE FORM:
CARVING PLASTER

Carvings made from different types of stone are often made from rectangular blocks. Since carving is a process of removing material to create the sculpture, it is important to visualize the shape of the sculpture inside the block.

This project will introduce you to the basic principles of carving. Megaliths or standing stones have been carved out of single rough blocks of stone. Long stones would have been selected for tall megaliths and shorter blocks would have been used for squarer or rounder shapes. Tall megaliths are often roughly rectangular and slightly sinuous, with rounded corners, wide front and back faces, and narrow sides. The front face is often a convex curve while the back may have a concave hollow.

Plaster is easily carved and can also be colored to give a marbled effect. In this project, a box is used to cast a rectangular block of marble-effect plaster.

Marbled plaster standing stone form.
The standing stone shape naturally fits inside a
rectangle, so it's easy to see where to carve in order to arrive at
the final form.

YOU WILL NEED
MATERIALS
Plaster
Water
Powder paints: yellow
 ochre, red, and blue

TOOLS
Paper and pencil
Cardboard box
Polythene sheet
Plastic bowls
Dust mask
Scoop
Spoons or sticks
Wooden board
Wood saw
Stiff brush
Colored chalk
Surform rasps
Upholstery foam pad
Chisels
Mallet
Flat stiff blade, such
 as an old knife
Steel wool
Clear furniture wax
 polish
Cloth

1 Draw the front, back, and side views of the standing stone to plan the carving of the block.

Line a cardboard box—a shoe box is a useful size—with a piece of polythene sheet, ensuring that there are not too many pleats and folds around the sides. To create the marbled effect, you need three different colors of plaster. Wearing a dust mask, mix up a substantial quantity of plain white plaster for the main bulk of the block (see page 54). Mix some yellow ochre powder paint with a little water in a small bowl and add plaster to a creamy consistency. Mix red powder paint with a touch of yellow and blue to make red-brown. Add plaster to the red-brown mix. You can make the marbling any color you wish by mixing different shades of powder paint.

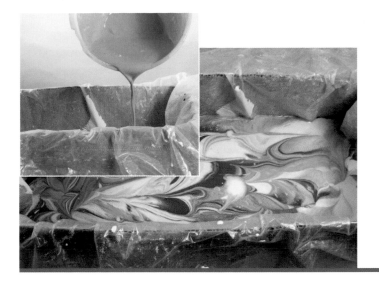

2 Pour some white plaster into the box, then add a little yellow plaster, and then some red-brown, pouring up and down to streak the color. Follow with more white plaster, then streaks of yellow and red. Continue until all the plaster has been poured into the box mold.

SAFETY
Always wear a dust mask when working with plaster powder. If you have sensitive skin, use a moisturizing cream on your hands when handling liquid plaster.

3 Let the plaster set and wait until the heat of reaction has cooled again before turning the block out onto a board. Use a wood saw to cut off any irregular edges from the base and top ends of the block.

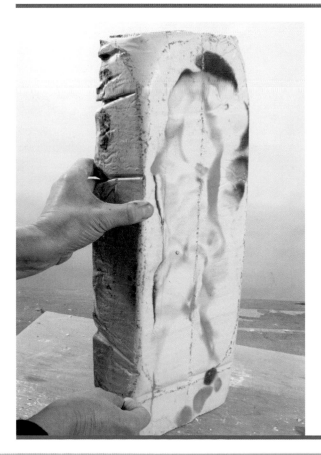

4 Make sure the bottom of the block will stand up without wobbling. Referring to the drawings made in Step 1, use colored chalk to mark out the standing stone shape on the plaster block. Draw a midline down all the faces, front, back, and sides. Make sure that the most prominent part of the front is close to the cast block's surface and that the widest part of the sides meets the width of the block.

TIP
The wet plaster will clog up the saw teeth very quickly, so keep cleaning the blade with water and a stiff brush. Have a bucket of water beside you for this purpose. Do not wash plaster down the sink because it will clog the drain.

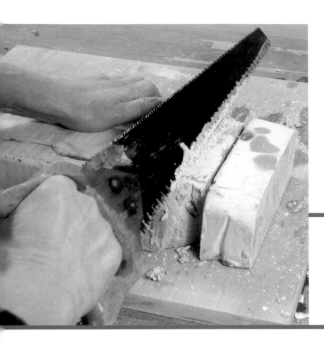

5 Mark a level line around the block about 2 in. (5 cm) above the bottom to make the plinth. Cut along the line with the saw about ½ in. (1.5 cm) deep all round. Make a second slanting cut to remove a wedge of plaster and shape the base of the standing stone and top of the plinth.

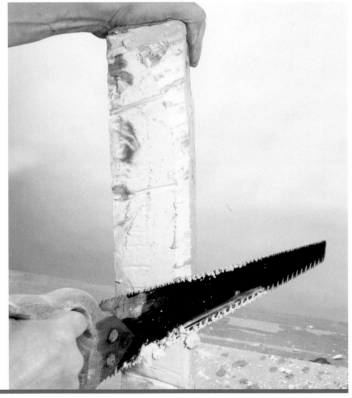

Use a chisel to gently pry away the sawcut wedge.

6 Cut down the corners of the block with the saw to bevel off the front and back of the standing stone.

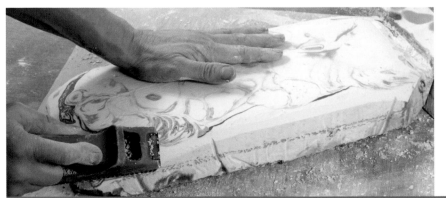

7 On a board, lay the block on its back and smooth off the cut corners with a surform rasp.

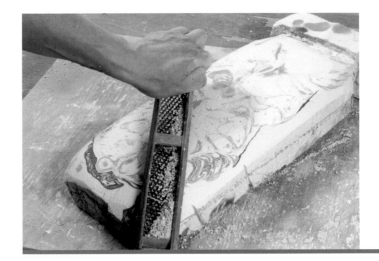

8 Work across the whole surface of the front with a rasp to reveal the marbling in the plaster. Curve the sides and top to create the convexity of the front.

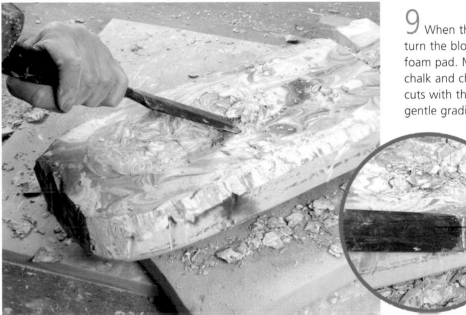

9 When the front has been well shaped, turn the block over and lay it face down on a foam pad. Mark the hollow in the back with chalk and chisel it out. Make small slanting cuts with the chisel and mallet to create a gentle gradient in the hollow.

Chisel away toward the sides of the block to make the backward leaning curve of the standing stone.

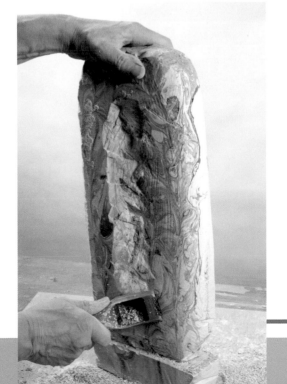

10 Round off the top corners of the block and stand it upright. It helps to think of the form like a human figure, with a hollow for the spine and swelling curves for the shoulders and hips. Smooth the hollow and curves with a small curved rasp. Using rasps, continue shaving away toward the sides until the standing stone has smooth rounded edges and a good sense of posture.

11 With rasps, work over the whole surface of the block, including the plinth, to fully reveal interesting marble colors in the plaster.

12 When you are satisfied with the shape of the standing stone, make a careful saw cut down each side of the plinth so that the sides of the stone are slightly wider than the plinth.

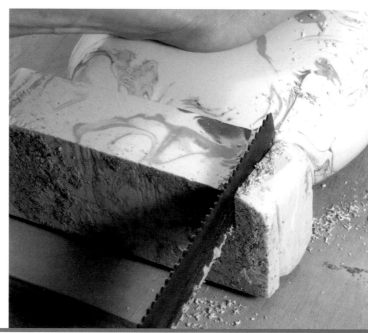

13 Smooth the rasp marks from the surface with a flat stiff blade such as an old knife. Crisscross the scraping to make the surface as smooth as possible. The old knife can also be used to whittle away any irregularities between the plinth and standing stone form.

14 Smooth over the whole surface with a dry steel wool pad. Rub lightly to get maximum smoothness after all rasp marks have been polished away.

SEE ALSO
Molding and Casting
Mixing Plaster, page 54

Carving
Carving Techniques, page 98

15 Allow the plaster to dry for at least one week in a warm place. Polish the standing stone with clear furniture wax polish.

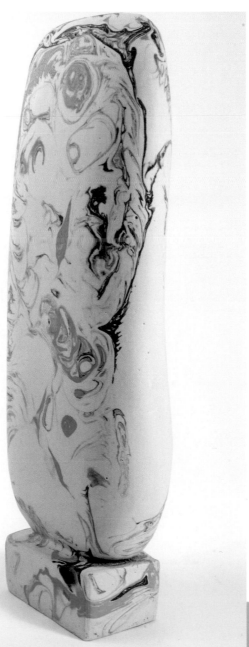

PHAROAH HEAD:
CARVING CINDER BLOCK

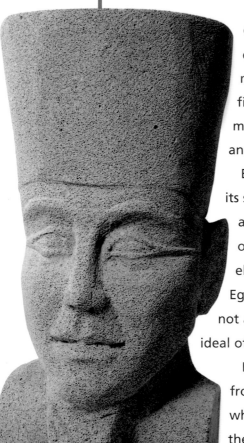

Cinder block, or aerated concrete, is a soft and easily cut material. It is ideal for carving because much of the process simply involves rasping and filing to establish the detail. Although it is a light material, the finished sculpture will have the solid and monumental qualities of a heavy stone.

Egyptian sculpture is famous for the quality of its stone carving. Huge statues of Pharaohs convey a sense of calm and stillness with eyes focused on a distant horizon. Part of this is due to an element of stylization used by the ancient Egyptians. Most of the sculptures of Pharaohs are not actual portraits. They conform to a standard ideal of beauty held by the Egyptians.

In this project, you will learn how to work from preparatory drawings and a clay maquette, which will be used as the small-scale model for the carving.

The Pharoah Head form has clean lines, with a geometric shape for the headdress, and smooth uncluttered features.

YOU WILL NEED
MATERIALS
Clay, economical variety for modeling the maquette
Cinder block

TOOLS
Paper and colored pencils
Colored chalks
Ruler
Wood saw
Chisels
Mallet
Rasps: surform and round
Files
Dust mask
Spray mister
Rifflers
Awl

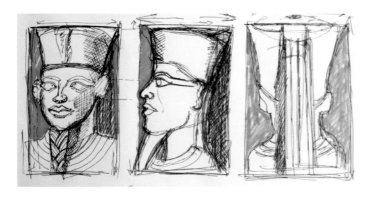

1 Make drawings of the front, back, and side views of the sculpture. It is a good idea to draw equal-size rectangles on the paper and fit the views of the sculpture inside these. Shade in the areas to be cut away in a different color. This helps to visualize how the form of the head will fit inside the block. Remember that carving is a process of taking away, so the final result will be smaller than the block you start with. However, you do not want to remove too much surplus material so make sure that the sculpture will be a good fit. The widest or highest points, such as the tip of the nose, the ears, or top of the hat, should meet or come close to the surface of the uncut block.

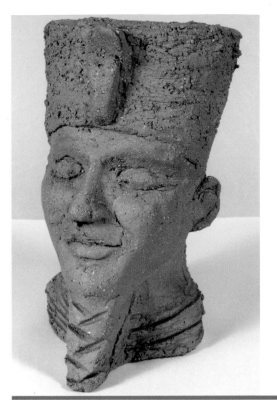

2 Make a clay maquette of the sculpture. This should be a small-scale model of the final piece. A maquette is extremely useful when carving a sculpture because you can turn it around, look at it from the top, bottom, and sides, and visualize the actual three-dimensional form you are about to carve. It does not have to be an exact model of your final piece: its main job is to keep the form in your mind's eye and serve as a visual aid for the carving.

SAFETY

Cinder block is a very dusty material, so before you start cutting, soak it with water for five minutes. Stand the block in the sink and pour water over the top. The water will soak in very quickly. The cinder block can be cut wet when using the saw, but for the later stages of filing it will have to be dry when worked. Wear a dust mask at this point and keep spraying the dust with water from a spray mister. Sweep away dust and chippings regularly.

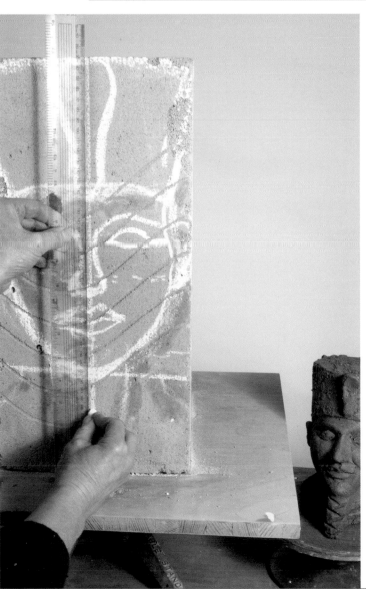

3 Mark out the wet cinder block with chalk. Draw vertical lines down the center of each side of the block, front, back, and both sides. Draw the face on the front and make horizontal lines to mark the level of the chin, eyes, tip of the nose, and top and bottom of the ears.

SEE ALSO
Clay Modeling
Preparing Clay, page 16
Project 1, page 26

Carving
Carving Techniques, page 98

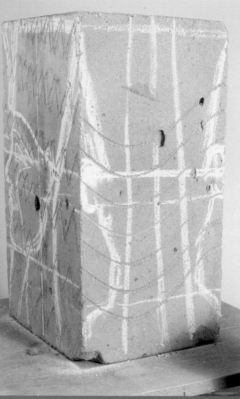

4 Continue to draw the horizontal lines around the sides of the block and across the back. This is an important step because you do not want one ear much lower than the other, or the eyes not level. It is easy to lose sight of one side of the block while you are concentrating on chiseling or filing the other side. Draw the profile on each side and the view of the back. Draw the shape of the top of the hat on the top of the block, then turn it upside down and draw the shape of the underneath. Keep checking your chalk marks and make any revisions in a different color.

5 With the cinder block on its back, use a wood saw to cut away a piece to shape the front of the hat and forehead. Work carefully with the saw because cinder block breaks easily.

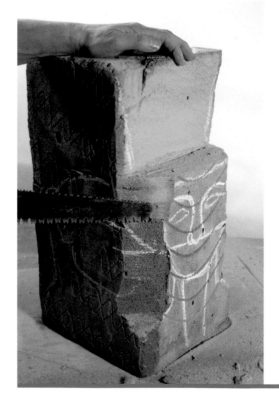

6 Stand the block up and make a cut down the corners to shape the cheek area of the face.

7 Make further cuts with the saw to form the nose, mouth, and jaw. They will now look like a set of ridges on the front of the face and some of the chalk drawing will have been removed. Redraw the face with chalk.

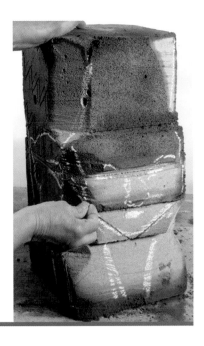

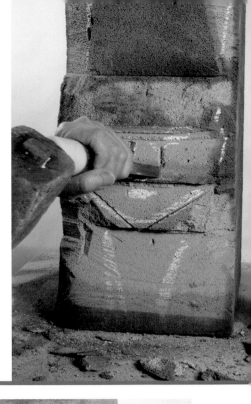

8 Work with a chisel and mallet to mark out the sides of the nose and the line of the jaw, only by digging in. Do not remove any material.

9 Once you have marked the lines, cut away with the chisel and rasp to develop the shape of the face.

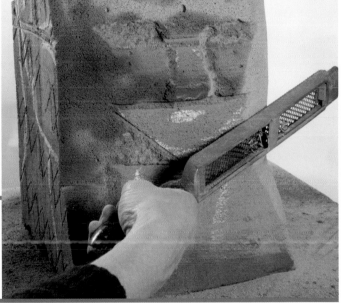

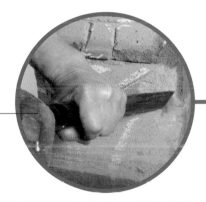

Carefully chisel the block to shape the face.

10 Now work on the sides and back of the sculpture. The hat has a triangular piece of cloth hanging down the back. Make two cuts with the wood saw, one along the edge of the triangular cloth piece and the other at the back of the shoulder. Work gently because the block crumbles and chips very easily. Use a chisel to remove some of the large pieces of excess material.

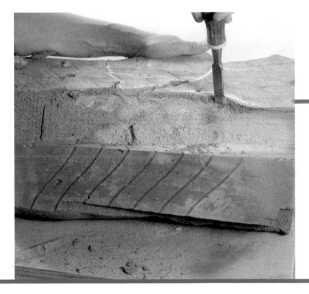

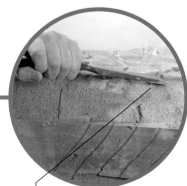

Work the chisel along the cut line, to keep a clean shape.

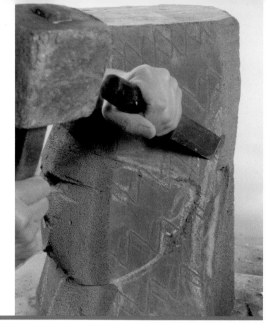

11 Continue carving off and shaping around the sides of the sculpture with a chisel.

12 Use the chisel blade to redraw the neck and head shapes on the cut-away parts. Use hand pressure to dig the chisel blade in to form a line.

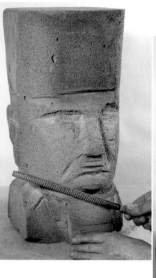

Smooth the contours with a rasp.

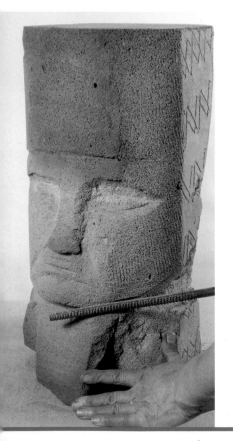

13 Look carefully at the side view and note the positions of the tip of the nose, the eyebrows, chin, and mouth. The nose sticks out the furthest, followed by the chin and mouth areas, but the eyes are set deep. Use a chisel blade to mark out the eyes and to dig away from the sides of the nose. Cinder block is so soft that you can work the chisel with hand pressure only. This is particularly useful for marking out the lines of features. Shape the jaw with a round rasp.

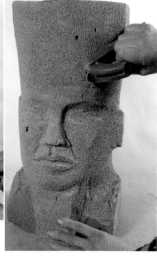

14 Continue working steadily around the head with rasps and files. Wear a dust mask and spray the sculpture and the air with water to keep dust down. Filing cinder block generates large quantities of dust, so regular cleanup is essential.

15 Mark the features to be carved, such as the eyes and nose, with chalk. Use a small chisel to shape and define the nose, lips, and behind the ears. Rifflers can be used to work fine details such as the nostrils.

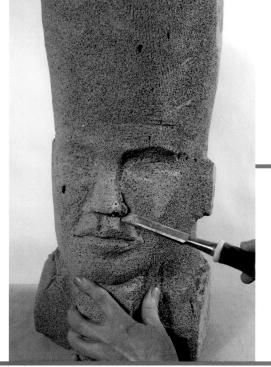

A curved riffler is ideal for shaping curves.

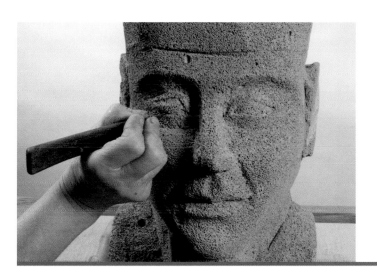

16 A small stiff blade or pointed tool such as an awl can be used to draw lines for the eyes.

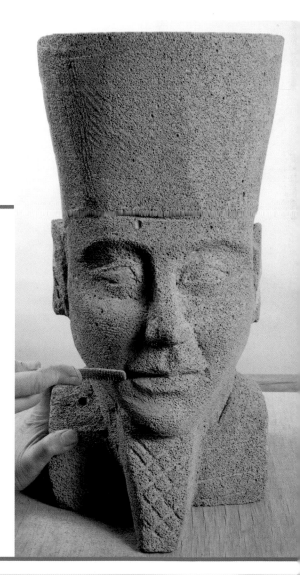

17 Rifflers come in a variety of shapes, so use these to finish off the eyes, the patterns on the beard, and the lips. When you are satisfied that the sculpture is finished, put it in the sink and wash it well to remove all remaining dust. Allow to dry.

EXPRESSIONISTIC HEAD:
WOOD CARVING

In this project, we make an expressive, semi-abstract head with wood carving. The sculpture is worked with free gestures to keep it lively and fresh. Too much surface refinement can result in a loss of spontaneity.

When working with wood, choose a size and shape to suit the sculpture you plan to make, then work directly into the wood.

Some wood carvers like to use a small domestic chainsaw, as was used for this project, but all the work can be done equally well with an axe. The axe requires time and patience: the chainsaw is much quicker, but it is advisable to have some training in using it. If you do choose to use a chainsaw, invest in a good-quality model because cheap chainsaws are often difficult to control for fine work, and always follow the recommended safety precautions.

Wood head carved by Simon Kent.
Finished with linseed oil.

YOU WILL NEED
MATERIALS
Large log of wood, preferably oak or chestnut

TOOLS
Cinder blocks or wood block
Small, good-quality domestic electric chainsaw (optional) and protective gloves, dust mask, safety goggles, and ear protectors
Axe
Fishtail chisels: large, medium, and small
Mallet
Adze
Gouges: medium and small
Electric sander
Linseed oil
Paintbrush

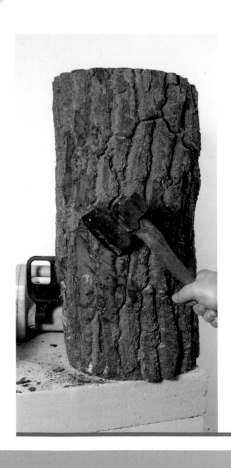

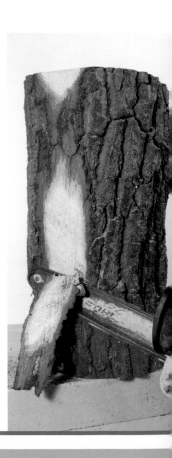

1 Select a log of a suitable size and shape for the sculpture. Stand it on a table on top of some cinder blocks or a block of wood to ensure you can work at eye level. Cinder block is a soft material, so if you accidentally catch it with the chainsaw or axe, little damage will be done to the blade. Start by chipping off the bark with the axe or by gently cutting away with the chainsaw.

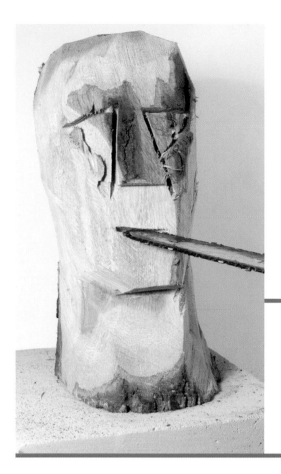

2 Remove all the bark from the front and sides of the head. Then start shaping the head, cutting planes for the cheeks and forehead. Mark the features by making cuts with the axe or chainsaw to indicate eyebrows, nose, and mouth.

Continue shaping the face and head in small slices using the axe or chainsaw.

3 Turn the head sideways to take a big cut out of the back to shape the neck, shoulder, and jaw. Remove any remaining bark from the back of the head.

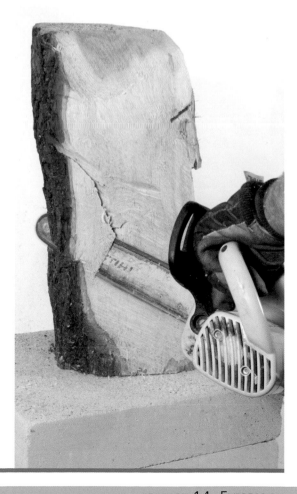

4 The next stage is to define the facial features. The nose is the most prominent part of the face, so wood must be cut away from either side. Make a deep cut along the sides of the nose, about 2–3 in. (5–7.5 cm) deep. Then start removing wood from the cheeks with a large fishtail chisel and mallet.

The cut at the side of the nose prevents the chisel from slipping or taking off part of the nose.

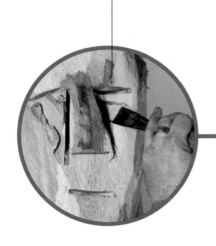

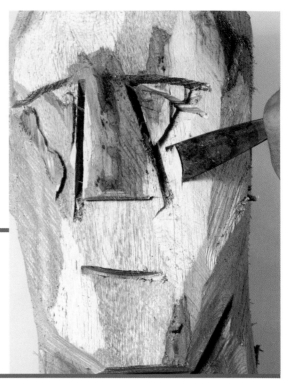

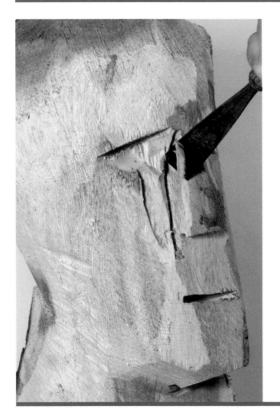

5 Carefully work toward the cut. This makes sure that the chisel cuts the wood cleanly and you can control the shaping. Use the fishtail to form the eye sockets and to shape the nose.

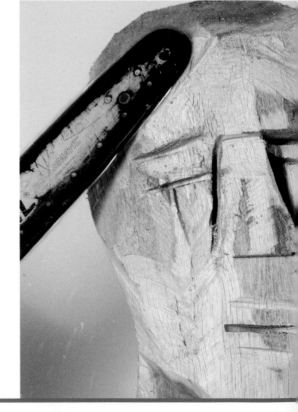

6 Shape the hairline by making a shallow cut with the chainsaw or axe, then trim wood away from the forehead.

7 Continue working around the sculpture with an axe or chainsaw to create the head.

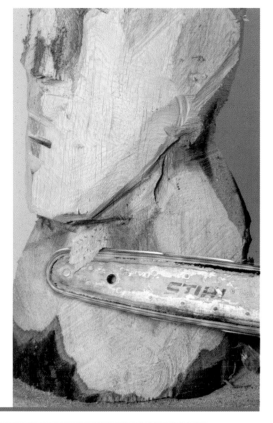

TIP

To achieve a fresh and spontaneous feel to the work, do not over-refine the sculpture. The finished sculpture shows the marks of the tools and movement of the hands. The sculptor of this piece has developed his own technique of delicate work with the chainsaw. He describes the chainsaw as his paintbrush. By just dabbing, brushing, or tickling the surface of the wood with the tip of the saw he is able to control the shape and surface of the sculpture, shaving it rather than cutting pieces off. An adze and axe can also be used to make tiny shaving cuts, but the marks have a slightly different character.

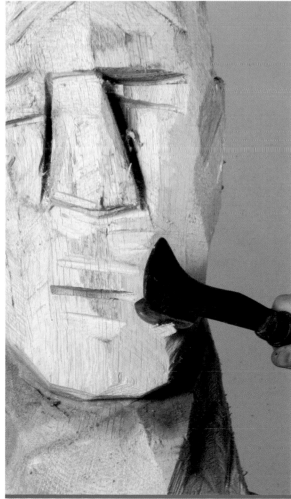

Refining with an axe.

8 As the head takes shape, make progressively smaller cuts with an adze or an axe.

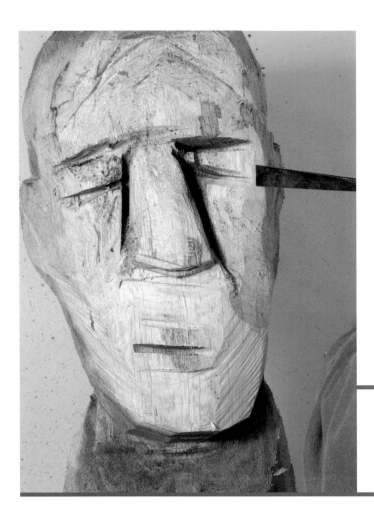

9 Form the eye with a medium gouge and refine the cheeks using fishtail chisels and gouges.

A small fishtail chisel is ideal for shaping the nose.

10 Turn the head sideways and make chisel cuts to mark the edge of the ear. Using a fishtail chisel or gouge, cut wood away from the head to leave the ear standing out.

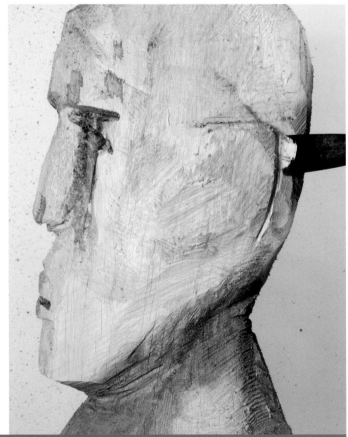

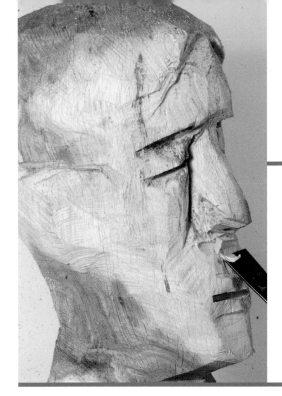

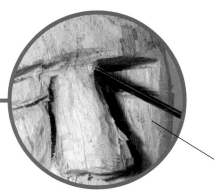

SEE ALSO
Carving
Carving Techniques, page 98

Use small gouges to deepen the eye sockets and shape the nose.

11 Use a fishtail chisel to form the indentation on the upper lip and create some definition around the mouth. Here, the sculptor has kept the suggestion of the mouth, just enough to give the face its sad and mournful expression.

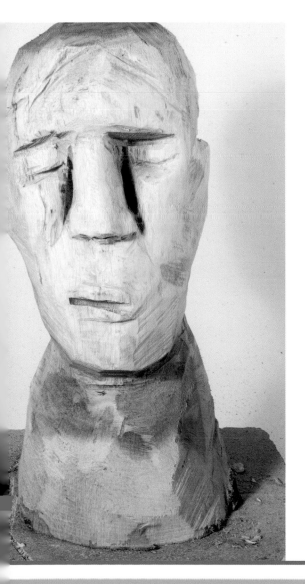

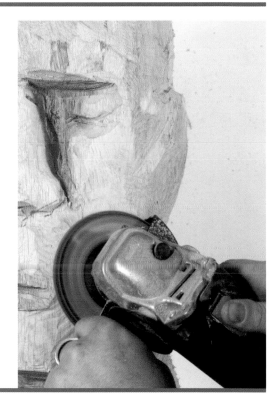

12 The aim is to create a human head that expresses emotion but at the same time retains the character of the wood. When you are satisfied with the sculpture, lightly sand off any splinters while taking care not to remove interesting tool marks on the wood.

13 The finished sculpture is the pale color of the wood, which can look rather dry and flat. The wood will need some protection, particularly if placed in the open air. Liberally brush on linseed oil. Work it into the wood by brushing all around the sculpture. At first, the oil looks very yellow but gradually soaks into the wood, bringing out the grain and giving a warm sheen to the finished piece.

CHAPTER 5

FINISHING TECHNIQUES

A VARIETY OF surface finishes have been used in the projects throughout this book. Some of the processes can be used equally well on clay or plaster sculptures, while other techniques can only be used on particular materials. Glazes, for example, can only be used when firing clay, but you can use paints to color sculptures of differing materials, including air-dried and bisque-fired clay, plaster, wood, metal, and canvas. Spray paints are suitable for fired clay or plaster sculptures, and metallic and special effect varieties are available from many hardware stores. Check them for durability, weather resistance, and drying times before you purchase them, and test them out before spraying an entire sculpture. Sculptures can also be waxed, polished, or oiled depending on the material used, so feel free to experiment with your own decorative ideas.

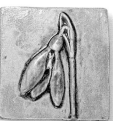

TOOLS AND MATERIALS

The tools you require will depend on the finish you choose. For example, you will want to use artists' brushes when painting with acrylic paints, but you won't need any tools for spray painting. A shoe brush or a cloth may be adequate for your choice of polish, but you will need to invest in good quality soft brushes if you plan to glaze.

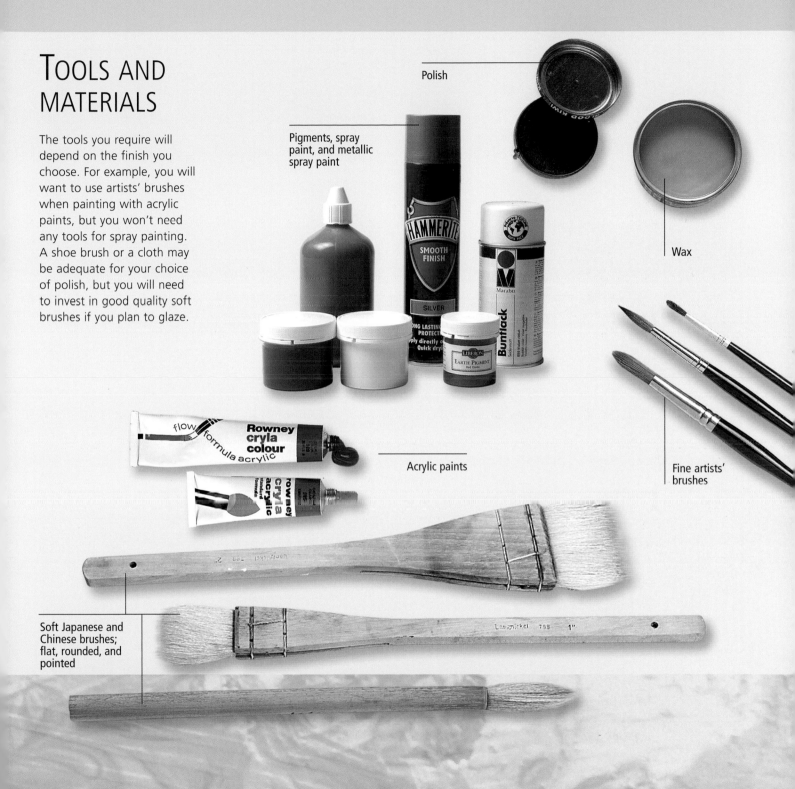

Polish

Pigments, spray paint, and metallic spray paint

Wax

Acrylic paints

Fine artists' brushes

Soft Japanese and Chinese brushes; flat, rounded, and pointed

SURFACE FINISHES

Acrylic paints, metallic paints, and polishes are all easy and inexpensive to use. Paints allow you to achieve detailed color and instant effect, while polishes can impart a level of sheen to suit your sculpture. They can be used on clay, plaster, or wood sculptures.

ACRYLIC PAINTS

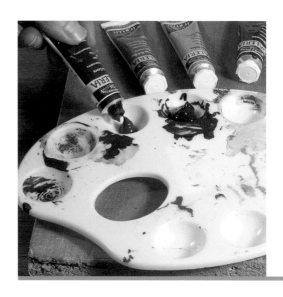

Acrylic paints are water-based and the simplest to use, whether on bisque-fired or air-dried clay, plaster, wood, or metal. You cannot fire clay after it has been painted with acrylic paint because the color would simply burn away.

Acrylic paints are bought in tubes like oil paints, but they dry very quickly, which is especially advantageous when you want to paint one color over another. Acrylic paints are opaque and can be thinned with a little water if desired, while brushes are easily washed with water.

Ways to mix and use acrylic paints are demonstrated below on the bird featured in Project 1, made from air-drying clay that has been sealed with hardener and allowed to dry.

REMEMBER
Acrylic paints set and dry quickly, so always remember to keep the caps on the tubes and to wash brushes before the paint on them dries.

YOU WILL NEED

MATERIALS
Sculpture made from air-drying clay with nylon fiber and sealed with the relevant hardener (see pages 26–29)
Acrylic paints

TOOLS
Paint palette and plastic spatula
Fine artists' brushes
Kitchen paper towel

1 Buying a boxed set of small tubes may be the most cost-effective way to purchase acrylic paints, but all the colors you need may not be included. You will need to mix your own shades on a palette. To mix black for the wing and tail feathers of this bird, I used dark blue, dark green, red, and a touch of yellow ochre, mixed well with a small plastic spatula.

2 Use a fine artists' brush to apply the black paint to the wing and tail feathers.

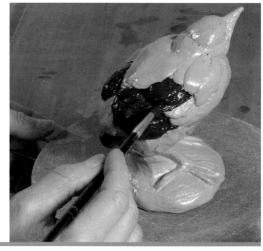

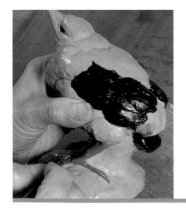

3 Mix some white paint onto a blob of the black to make a dark gray for the legs and back feathers.

4 For the downy head, shoulders, and breast feathers, mix up a soft yellowy-beige using yellow ochre and white paints.

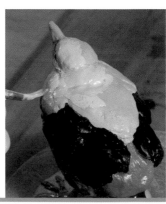

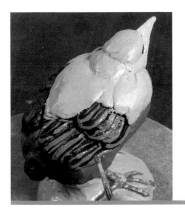

5 Add more white to the dark gray mix to create a pale gray. Pick out the edges of the wing feathers with pale gray and a fine brush. The rings around the bird's legs and the foot joints can be picked out with tiny brushstrokes of the beige or pale gray.

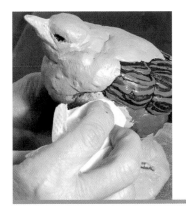

6 To create a downy texture over the dark gray body feathers, try softening with pale gray. Do this by brushing on some pale gray paint then blotting it selectively with paper towels to suggest the texture of fine feathers.

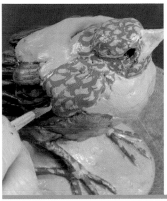

7 Now paint in the small feathers on the head, breast, and shoulders using a soft brown. With a fine brush, start on the head above the beak and paint small half-loop shapes to represent the feather edges, working out toward the wings.

8 Finally, dot black paint into the eye hole and pick out the beak and eyelid in yellow. If you wish to give the bird a shiny finish, wait until the acrylic paint is dry before applying another coat of gloss hardener.

METALLIC PAINTS

Metallic spray paints are very easy to use and suitable for bisque-fired and air-dried clay or plaster sculptures. The use of spray paints is shown in Projects 7, 10, and 11 (see pages 62–67, 84–89, and 90–95). Most of these paints dry rapidly, allowing for further surface treatment to then be carried out. Gold, silver, copper, and bronze metallic paints can be obtained from hobby and craft stores. Other possibilities are paints used for motor vehicles, which are durable and weatherproof and offer a wide range of colors, including metallic finishes.

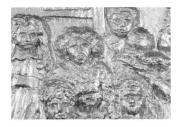

SAFETY
When using any kind of spray paint, always work in a well-ventilated area and wear a dust mask. It is also a good idea to protect work surfaces and any adjacent walls with plastic sheeting.

POLISHES

Polishes give a good finish to many materials. Wood can be treated with wax polish, and clear furniture wax will give a good sheen and seal the surface of smooth plaster. This is recommended for finishing the plaster standing stone in Project 12 (see pages 100–105).

Some polishes are densely pigmented. Red floor-tile polish has been used to finish the head in Project 5 (see pages 46–51), while black graphite stove polish was used on the cement fondue toad in Project 9 (see pages 74–79).

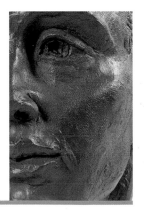

FIRING CLAY

Clay is a wonderfully versatile material for forming sculpture or pottery. When soft and plastic, it can be modeled and shaped. At the stiff, leather-hard stage it can be cut and used to make rigid forms with flat surfaces. As a liquid slurry—known as slip—it can be colored with commercially available stains and cast into molds or painted onto pots and sculptures as a decorative surface color, as in Project 3 (see pages 34–39).

Hard, dry clay will keep its shape, but it is brittle. If soaked in water it will collapse into a liquid slip. To make a clay form permanent, it must be baked to a high temperature in a kiln. This is called firing. The firing heat removes all water mixed in with the clay and converts the clay into a form of stone. The higher the firing temperature, the more stone-like the clay becomes. Not all clays are capable of withstanding very high firing temperatures so the clay suppliers provide information on the firing range of the clays they produce.

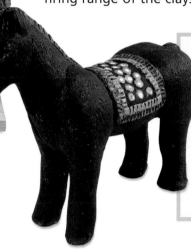

Left, an unfired horse with saddle detail decorated with black, brown, ochre, and white slips.
Right, the slip-decorated horse after firing to 1,832°F (1,000°C). Note how the colors have changed.

BISQUE FIRING

Clay is normally fired in two stages. The first stage is the bisque firing, where the clay is heated slowly up to a temperature of 1,832°F (1,000°C). The fired clay is now made permanent but is still porous.

After bisque firing, the clay can be treated in a variety of ways. It can be painted, polished, or subjected to further firing with or without glaze.

Project 2, Shell Form, was bisque fired prior to sawdust firing.

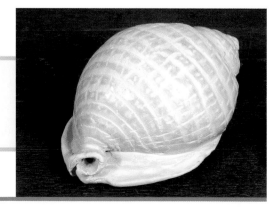

SAWDUST FIRING

YOU WILL NEED
MATERIALS
Bisque-fired clay sculpture

TOOLS
Kiln bricks or house bricks
Newspaper
Sawdust
Kindling
Matches
Old kiln shelf

Interesting effects can be obtained by sawdust firing, or smoke firing, clay objects. This technique produces the best results on smooth clays that have been burnished. Sawdust firing has been used to finish the burnished shell forms made in Project 2 (see pages 30–33). Dry clay pieces can be sawdust fired but are very fragile, so it is advisable to bisque fire the work to 1,796°F (980°C) beforehand. This is a low bisque temperature that is high enough to strengthen the clay without losing the burnish. Higher temperatures cause the burnish to lose its shine, although the surface of the clay will remain smooth.

1 A typical sawdust kiln is built from a circle of bricks. Ordinary house bricks can be used, though the example here was made from spare kiln bricks. Lay a bed of crumpled newspaper and sawdust at the bottom of the kiln.

2 Nestle a bisque-fired clay sculpture, such as the shells from Project 2 (see pages 30–33), down into the kiln.

3 Pile more sawdust on top to completely cover the shells to a depth of about 3 in. (7.5 cm). Put newspaper and kindling wood on top of the sawdust and light a fire.

4 When the fire is well lit, place a lid over the kiln—an old kiln shelf will do—and leave it to smolder for several hours.

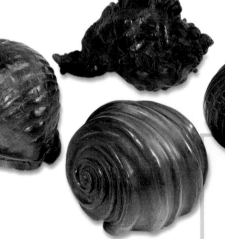

As the sawdust burns down slowly, it leaves carbon markings in the clay. These marks are random and give a spontaneous, natural finish to the work. Sometimes a piece will come out dark and smoky in appearance, and sometimes there are more variations in color, with speckles and patches of pale gray or deep black.

Glazing

Glaze is usually applied to a bisque-fired piece, with the glaze functioning as a sealer as well as surface decoration. Glazes consist of glass-forming materials combined with other ingredients that control the melting temperature and qualities of the finish, such as gloss or matte and shade of color. More like a cake mix that starts off as a pale paste and turns to a golden-colored sponge after baking, a glaze mix will give little indication of the final fired color or texture. Therefore, when buying ready-mixed glazes, it is important to refer to the supplier's catalog colors and fire your own tests on small samples of clay before applying a glaze to a whole sculpture.

Brush-on Glazes

You will need

Materials
Female torso cast from semi-porcelain clay (see pages 68–73)
Pottery wax
Glaze

Tools
Household paintbrush
Glaze brush
Sponge

There are several methods of glazing pottery or sculptures, such as dipping the piece into the glaze, pouring the glaze over the object, or spraying or brushing on the glaze. In this book, brushing on glaze has been demonstrated because it is the most straightforward method of glazing, and also because some of the other methods can be difficult to use on awkwardly-shaped sculptures. Although the glazes shown are my own recipes, ready-mixed brush-on glazes are used in exactly the same way, and are easily obtainable from pottery suppliers in a wide range of colors and textures.

Glazes can be brushed onto bisque-fired clay (page 120) or directly onto dry but unfired clay. Glazing unfired clay is known as raw glazing. For beginners, it is advisable to work with bisque-fired pieces until you are confident with handling clay and glaze.

Glazes have been used in Projects 6 and 8 (see pages 58–61 and 68–73).

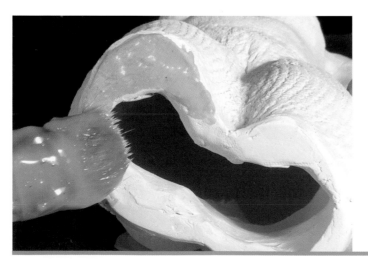

The female torso, featured in Project 8, is finished with a yellow speckle glaze. On page 68 the torso is finished with a gray-green glaze.

1 First, wax the base of the sculpture to keep it glaze free. The wax can be bought as an emulsion from pottery suppliers. Use a household paintbrush to paint on the wax.

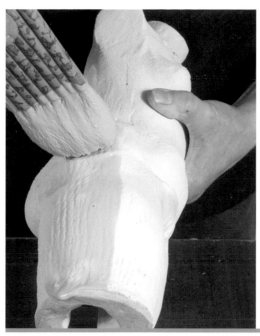

2 Use a glaze brush to apply a coat of glaze as evenly as possible. It dries in a few seconds.

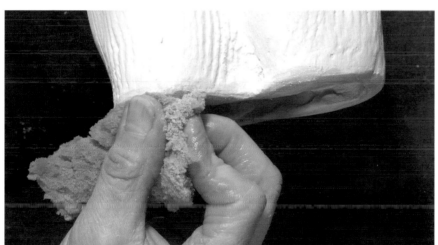

3 Apply a second coat of glaze in the same way. Brush on a third coat and then wipe off any glaze drops from the base of the sculpture with a damp sponge. The sculpture is now ready for firing.

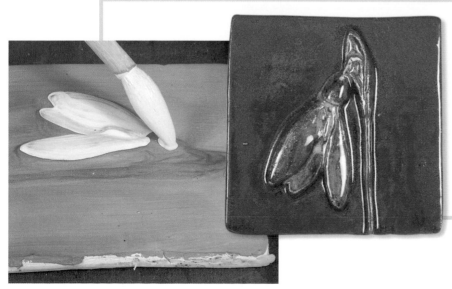

Two different-colored glazes have been used on this tile to pick out the design of the snowdrop. The back of the tile and lower edge of the sides were waxed, and three coats of red glaze were brushed on as evenly as possible. The second glaze was painted over the flower with a pointed brush, and produced a blue speckle when fired. On page 58 the snowdrop relief is finished with a matte green glaze.

Glossary of Terms

Adze A special type of axe used in wood carving.

Armature A rigid internal support for a modeled sculpture. It can be made of wood or wire to create a framework for the sculpture.

Balloon armature Type of armature used for modeling heads, consisting of a wood post and two wire loops joined together.

Bisque firing The first stage firing of clay or ceramics before applying a glaze.

Block A lump of material such as wood or stone that is to be carved.

Bloom Cloudy film left on the surface of a cast, such as on cement fondue cast in a plaster mold.

Callipers A tool for measuring 3-D objects consisting of two curved arms hinged together.

Carborundum Silicon carbide block used for filing and grinding.

Cast A sculpture produced from a mold.

Cement fondue A gray-black alumina cement used in concrete sculpture.

Clay wash A thin clay slip used to coat the seams of a plaster mold to prevent the parts of the mold sticking together (see also release agent).

Cure The hardening process of a material that is initially worked in a fluid form such as concrete or resin.

Firing The process of baking clay in a kiln to harden it permanently and also to fuse glaze to the surface.

Glass fiber A mesh of glass filaments bonded into sheets or mats which can be used to reinforce concrete or resin sculptures.

Glaze A glassy coating that seals and decorates ceramic ware. It is applied as a liquid and hardened and fused to the clay by firing in a kiln.

Gouge A wood carving chisel with a curved cutting edge. Gouges are usually U-shaped but can be V-shaped for use in engraving.

Grog Ground particles of fired clay that are added to some clays to give them strength.

Hollow building A technique for making clay sculpture in which the form is built from slabs and tubes of damp clay so that it is hollow throughout.

Key A small interlocking device in the seam of a mold to ensure that the parts of the mold are correctly located when put together (see also natch).

Kiln Special oven or furnace for baking clay and ceramics.

Leather-hard A description of clay that has become stiff but not completely dry and rigid.

Maquette A small preparatory model for a sculpture, often made of clay.

Mat Sheet of material made of glass fiber strands used in reinforcing concrete or resin sculptures.

Natch A keying technique for locating the seams of a mold.

Patina A colored coating which forms on the surface of metal sculptures due to the action of weather or artificial agents.

Plasticity The character of a material that can be molded and modeled into shape, such as clay or wax.

Polystyrene Type of plastic that is often supplied as light granular blocks or sheets. Also known as Styrofoam.

Porcelain A clay body high in china clay. It is very white and often translucent when fired.

Primer Undercoat applied to the surface of a sculpture to seal and prepare it for painting.

Rasp A coarse abrasive metal tool with a surface of tiny raised teeth.

Release agent A substance applied to the seams or interior of a mold to prevent adhesion (see also clay wash).

Riffler Small metal filing tool, used in carving wood or stone.

Scrim A loosely woven hessian fabric, used in reinforcing plaster molds and casts.

Separator A substance used to prevent casts adhering to the inside of a mold (see also soft soap).

Slabbing A technique in which a form is built from thick sheets of damp clay.

Slip An opaque creamy liquid made form clay and water. Slip can be colored and used to decorate clay sculptures.

Slurry A mix of cement and water that is applied as a first coat to a mold when making hollow cast concrete sculptures.

Soft soap Type of liquid soap that is diluted with water and applied to molds to prevent adhesion of a cast or mold sections.

Stoneware A range of buff, gray, or white clays that can be fired to high temperatures for durability and strength.

Surform Metal abrasive tool with a replaceable blade, like a grater. Used for filing soft materials such as clay, wood, or plaster.

Tamping Process of compacting a material such as concrete in a mold.

Template A shaped sheet of paper or thin rigid material used as a guide for forming parts of a sculpture.

Terracotta Fired clay sculpture, usually made from red earthenware clay.

Undercut Recess or awkward angle in a sculptural form that prevents easy removal of the cast from a mold.

Waste mold A mold which can only be used once to release a cast by breaking it away. Used for intricate forms where undercuts cannot be avoided.

Wedging Process of mixing clay to ensure an even consistency.

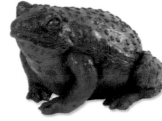

INDEX

CREDITS

Quarto would like to thank and acknowledge the following for supplying photographs reproduced in this book:

t = top; b = bottom; r = right; l = left; c= center

9b courtesy of Potclays
www.potclays.co.uk
11br Bernard McGuigan
12b Patricia Volk

All other illustrations and photographs are the copyright of Quarto Publishing plc. While every effort has been made to credit contributors, Quarto would like to apologize should there have been any omissions or errors—and would be pleased to make the appropriate correction for future editions of the book.

AUTHOR ACKNOWLEDGMENTS
This book is dedicated to my partner, family, and friends.
I would also like to thank Simon Kent and Geoff Morgan for their contributions to this book.

REFERENCES

The Complete Guide to Sculpture Modelling and Ceramics: Techniques and Materials
Barry Midgley
Grange Books 1997
ISBN 1-85627-971-5

The Manual of Sculpture Techniques
John Plowman
A & C Black 2003
ISBN 0-7136-6580-7

The Sculptor's Bible
John Plowman
Krause 2005
ISBN 0-89689-194-1

The Sculptor's Handbook
Stan Smith and H. F. Ten Holt
MacDonald & Co Ltd 1984
ISBN 0-356-10573-3

Modeling the Head in Clay
Bruno Lucchesi and Margit Malmstrom
Watson-Guptill Publications 1996
ISBN 0-8230-3099-7

Terracotta: The Technique of Fired Clay Sculpture
Bruno Lucchesi and Margit Malmstrom
Watson-Guptill Publications 1996
ISBN 0-8230-5321-0